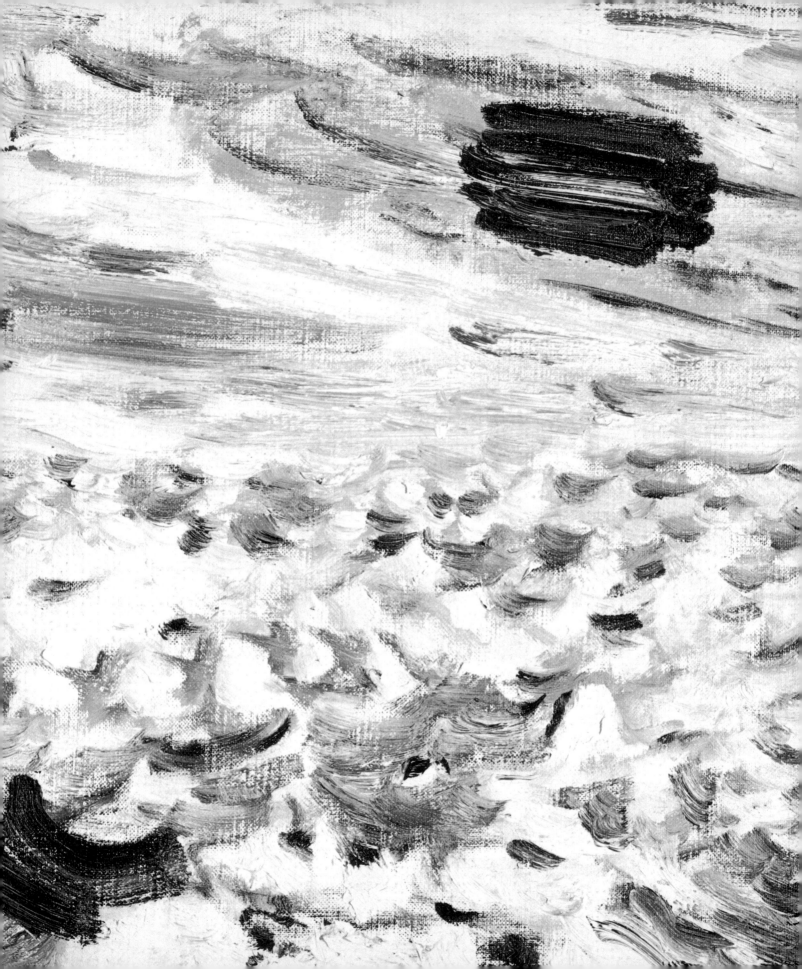

JOHN MARIN / 1870-1953

A Centennial Exhibition
Organized by the
Los Angeles County Museum of Art
Selection and Catalog by Larry Curry

Los Angeles County Museum of Art
July 7 - August 30, 1970

M. H. de Young Memorial Museum, San Francisco
September 20 - November 7, 1970

The Fine Arts Gallery of San Diego
November 28, 1970 - January 3, 1971

Whitney Museum of American Art, New York
February 18 - March 28, 1971

National Collection of Fine Arts, Washington, D.C.
April 23 - June 6, 1971

PREFACE AND ACKNOWLEDGMENTS

In spite of John Marin's natural aloofness, his lack of concern for fame and public adulation, and the restricted exposure of his art during his long association with Alfred Steiglitz, his painting has not gone unrecognized. Many distinguished scholars and friends of the artist have done much through the years to evaluate his work and see that it received the enlightened attention it deserved. More recently, his real stature has been forcefully projected through major exhibitions, including the memorial retrospective organized by Frederick S. Wight at the University of California at Los Angeles and the important exhibitions prepared by Sheldon Reich for the University of Arizona, the University of Utah and the Philadelphia Museum of Art. It is likely, however, that when future histories of American painting are written Marin will figure much more prominently than he has in those published heretofore.

Many interested people have been determined to see a major exhibition brought forth to celebrate this centennial year of the artist's birth; it was only a question of where it would be organized and presented. Thanks to our Senior Curator of Modern Art, Maurice Tuchman, whose first look at a few of the exciting works in the Estate of the artist at Marlborough Gallery convinced him that Marin was worthy of even greater attention today, the Los Angeles County Museum of Art has enjoyed the privilege of initiating this project.

Of all those who have contributed to the realization of this exhibition, John Marin, Jr. must be singled out for special effort. He and Mrs. Marin have worked tirelessly during the past months offering every assistance in the selection and preparation of works. Essential to the success of the show has been the generous cooperation of Donald McKinney, Director of Marlborough Gallery, who offered complete access to the large collection of paintings and drawings from the Estate. We are grateful for invaluable advice and information from Sheldon Reich whose monumental study of Marin and his work are now at the press. The generosity of all the lenders, which made this exhibition possible, will undoubtedly be appreciated by the thousands who will view these excellent examples of the artist's work.

Within this Museum many have worked diligently in handling the myriad details of organization. Nancy Wall is to be commended for her efficient preparation of the catalog list and bibliography.

Published by the Los Angeles County Museum of Art
5905 Wilshire Boulevard
Los Angeles, California 90036

Copyright 1970 by the Los Angeles County Museum of Art
Library of Congress catalog card number 77-128147
SBN 87587-038-4

Contents

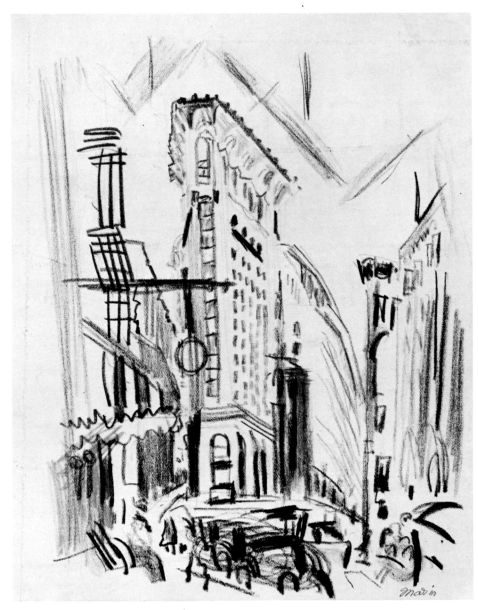

UNTITLED (FLATIRON BUILDING, NEW YORK CITY), about 1924

FOREWORD

The decadent, the revoltè, the man with a new vision, a new way, a finer
perception, is always a danger to the community of dullards, to the stratified
hierarchy of saintly academicians and embalmed mediocrities.

Benjamin De Casseres, 1910

John Marin belongs to that generation of artists who spanned the gap between the
nineteenth and twentieth centuries. Like his contemporary Henri Matisse, Marin's
achievement, both its strength and limitations, cannot be fully understood without
a knowledge of the extent of his connection with the older culture of the late nine-
teenth century. Yet, along with Matisse, his ultimate accomplishment is uniquely
twentieth century.

Looking over the large numbers of Marin's works, a few things emerge from
the beginning which remain true to the end. For one, he started as a landscapist,
expanding into cityscape, and only rarely essayed into the realm of figure painting.
In addition, whatever the subject his intent was not to render the outer structure
of reality, but to use the real world as a vehicle to express inner feelings. Finally, he
chose at the very outset of his career to convey ideas through watercolor.

The epoch in which Marin first grew to maturity—Late Victorian, Edwardian,
or in American nomenclature The Gilded Age—is understood as being complex.
In the arts a wide range of styles were acceptable and, indeed, practiced. The
country had not yet fully recovered from the trauma of Civil War. Artists who pros-
pered during these times were those who aided their patrons in forgetting the ugly
memory of the past conflict. Thus, artists covered reality with a haze which com-
fortably veiled the more unpleasant facts of the moment. Industrial barons, who
were the chief patrons of the arts, sat in Gothic mansions or French Renaissance
chateaux with light filtering through richly stained-glass windows and falling on
equally rich golden hues of oak, mahogany, and leather. On the paneled walls
gilded frames surrounded glowing landscapes of an idyllic world.

The tone set by artists' clients during Marin's youth may be recreated by a
description of a reception in the New York studio of the famous sculptor
Augustus Saint-Gaudens:

In the reception room at the Thirty-sixth Street studio, there were two sets
of curtains to hang behind the platform—black velvet if the work were in
plaster, white if it were in bronze. Ladies were invited and Gussie [Mrs.
Saint-Gaudens], if she felt well enough, would be there to sit behind a tea
table decked out with ... white Japanese cups ... Wine and cake would be
served at the reception as well as tea—a Paris custom ... Now, in New York,
it was very much the thing among Americans who remembered Paris days
*with nostalgia ...**

*Louise Hall Tharp, Saint-Gaudens and the Gilded Era (Boston and Toronto, 1969), p. 201.

1

John Marin's watercolors through 1912 fit within this refined, Henry James vision of the world. Such qualities were admired by James Huneker in his 1911 review of the artist's pictures:

Mr. Marin is an artist who knows how to spot paper so sincerely that the illusion of atmosphere, the illusion of a woman sitting, the illusion of a general reality, is evoked with non-essentials eliminated.

What happened to shatter this elegant view of a fuzzy world was Marin's contact with progressive French painting, Alfred Stieglitz, and the atmosphere of the Photo-Secession Gallery known as "291."

When in 1905 Marin visited Europe and stayed in Paris, he was following an old custom among artists in America. From Colonial days, those who could afford it, travelled to London, Rome, Florence, Dussseldorf, Munich and, of course, Paris. In these seats of European culture, they received an education as artists not possible at home. Marin upon arriving in Paris entered the atelier of Delecluse but like others before him, he abandoned the academic way to paint on his own.

His disillusionment with Delecluse did not lead him to Matisse and the Fauves. Instead, he was most influenced by Whistler, Signac, and Bonnard. Whistler reinforced Marin's inclination toward a softly evocative art, while Signac and Bonnard offered him a way to stiffen the structure of his still poetic images of French countryside.

Marin met Edward Steichen in France, and through Steichen, Stieglitz. Alfred Stieglitz changed the course of Marin's life and art. The Photo-Secession Gallery—the place, as Marin called it—was made "by the locating there of a man and a small group of kindred spirits gathered about him." John Marin acknowledged readily that "291" was held together, given its special power, by Stieglitz. Of this fact, Marin wrote:

A place that is never locked for those who can produce a key.
A place that is never locked to anyone—anyone can enter and walk about—but if one got nothing then the Inner remained closed—they hadn't the key.
To realize such a place—a very tangible intangible place was and is this man's dream.

Here at "291" Marin saw pictures by Cezanne, Matisse, Picasso, Braque, and Severini; children's art; and African sculpture. Here too he became a central figure in a group of avant-garde American artists which included Arthur Dove, Marsden Hartley, Alfred Maurer, Georgia O'Keeffe, Abraham Walkowitz, and Max Weber. Here it was in 1912 that he presented to the public his now famous paintings of New York—twisting, bending, bursting with Futurist energy—which hurled him into the center of twentieth century art.

No single line of experimentation dominated Marin's efforts of the teens. His scenes of New York continued within the dynamic framework of a highly person-

alized Futurism; he toyed with Cubist planes in pictures of the countryside. More often, however, heightening his color, working with a new found vigor, he passed from the pale symbolism of the nineteenth century to the forceful expressionism of the twentieth century. The metamorphosis complete, he followed, albeit somewhat slower, the course Matisse had also taken.

The twenties saw the emergence of the Marin myth — the legend of the self-made artist. In 1922, A. E. Gallatin stated it this way: "Winslow Homer and John Marin, two of the greatest painters which this country has produced, are both essentially American, as regards ancestry and freedom from the influence of foreign masters..." Gallatin was wrong, even about the purity of Marin's ancestry. Nevertheless, in an America fast turning inward, the identification of Marin with a thorough Americaness, helped his reputation to survive the wave of isolationism which innundated many other modern artists. Thus arrived the image of Marin as "A shouting spread-eagled American," self-taught, masculine and, while an artist, not overly interested in art. However, under this protective cloak, he continued to produce some of the most provocative and advanced paintings being done in this country.

The 1920s also saw Marin reach his full power as a watercolorist with a style often loose, spontaneous, prophetic of the Action Painting of the fifties. But the thirties are notable for oil paintings. This was the decade of the great seascapes, stressing the theme of wave smashing on rock, painted thickly, as if Marin exalted in exploiting those characteristics of oils which are different from watercolors.

Looking over the pictures of the twenties and thirties, we see that Marin had used the lessons of Futurism and Cubism in evolving a quasi-geometrical framework onto which he could graft his intensely personal reflections of the world. Before this time, however, from about 1914 to 1919, he had frequently employed a delicate color calligraphy in his paintings of landscapes — what Henry McBride called Marin's "Chinese hieroglyphics." In his late pictures, Marin returned to this interest in calligraphy, only the late line seems stronger, less pale and fragile. In this formal reduction to line of his total artistic means, Marin arrived, as one critic observed, at a point where the avant-garde (of a younger generation) was just beginning.

Today, one hundred years after his birth, Marin's historical significance as a major painter of the first half of the twentieth century is secure. Yet, unlike many other historically significant artists of his time, Marin's art retains the youthful qualities Jerome Mellquist observed in 1934: "Over and over again, in accents wild, hoarse, gleeful, and always melodious, John Marin's paintings...salute the world."

Sheldon Reich

When John Marin was born a hundred years ago, his eyes first opened on a world in which John Frederick Kensett, Asher B. Durand, Jasper Francis Cropsey, Worthington Whittridge and other great lights of the Hudson River School were still devoting their art to the celebration of the grand and unique character of the American landscape. Winslow Homer and Thomas Eakins were young men already dedicated to creating great art out of the raw material of the American scene. They had all worked to some extent on foreign soil but this experience was not entirely essential to their ultimate contribution as artists. For the younger generation developing in the eighties and nineties, study in Europe was considered absolutely necessary, and Europe meant Paris. Some came home to create an American style of Impressionism; others embraced the ideas of more conservative teachers. Unlike so many of his contemporaries, however, Marin never really belonged to Europe, nor to the nineteenth century. From the moment he began to pursue his career in earnest, about 1911, his work was highly original, in many respects paralleling that of the avant-garde in Europe.

When Marin's mother died soon after his birth at Rutherford, New Jersey, his father took him to Weehawken to live with his maternal grandparents, Richard and Eliza Currey, whose household included an Uncle Richard Currey and two maiden aunts, Lelia and Jenny. Here, Marin grew up in an atmosphere ''...as thoroughly Yankee as apple pie and baked beans.'' [1] His education in the schools of New Jersey was interspersed with long summers of hunting, fishing, and sketching, and in 1886 he ventured into the Catskills to make careful sketches of the landscape which had inspired an earlier school of artists. Two years later he was working around White Lake in Sullivan County, New York, and making sketching trips as far afield as Wisconsin and Minnesota. Even during these early years Marin developed a profound communion with nature which was to be infinitely more important to him than any art lesson. The preference for landscape as a subject for his art was established.

Throughout the nineteenth century the artists of this country who were most self-reliant in terms of training have tended to produce the strongest and most enduring work. John Marin brings this national characteristic into the twentieth century, and retains it even after the advent of a thoroughgoing international modernism. Formal training was almost incidental to his development as an artist. Experience in four different architects' offices and a brief period as a free-lance architect in 1893 undoubtedly had some effect on his ability to control line and form, but the measured line of the drafting table is not easily adapted to subjective interpretation of landscape. More important was the instinct for drawing and the

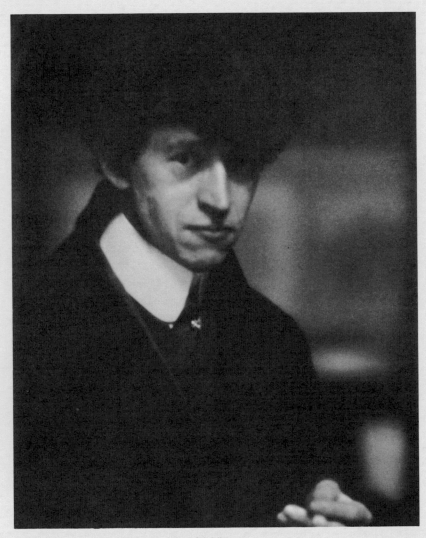

John Marin, 1910. Photograph by Alfred Stieglitz.

years of striving to set down the visual qualities of his environment. When he began to study at the Pennsylvania Academy of the Fine Arts, neither the ideas of Eakins' successor, Thomas Anchutz, nor those of the Munich-trained William Merritt Chase, seemed to have much influence upon his work. He had the usual distaste for drawing plaster casts from Greek and Roman sculpture, and when he won a prize for drawing, it was not for his studio work but for the sketches made in the field around Weehawken. The value of his brief enrollment at the Art Students League in New York was questionable also. In his own opinion he "...derived very little from that period." [3]

Like the early American artists, Marin made avid use of illustrated magazines and books and other engravings as a source of learning. A drawing of the head of a burro copied from an engraving after Rosa Bonheur (Private collection, New York) is proof that the artist had already achieved remarkable skill in his teens. The facility with which his pencil has reproduced the effects of line and tone in the engraving is truly amazing. [4] To Marin, however, this kind of work was little more than mere exercise, and watercolors from the preceding year at Whitelake, Sullivan County, New York (plate 1), make it clear that the concern for formal problems and the desire to exploit the particular quality of the medium in hand were there from the beginning. Subsequent drawings and watercolors from this period indicate an increasing sophistication.

To these years belongs also the question of the famous *Weehawken Sequence,* consisting of about a hundred small oil paintings on canvas board. Marin himself placed these works in the years 1903-04 and his biographer, MacKinley Helm, made much of the way they related to his life at the time. [5] If these dates are firm, these paintings represent a milestone in the history of art. Ranging from a daring representational style to almost complete abstraction, they would anticipate both the later work of the Fauves (plate 5) and the advent of abstract art in 1910 in the art of Wassily Kandinsky and Arthur Dove (plate 9). After years of intensive research, Sheldon Reich no longer accepts this possibility, suggesting instead a later date of about 1916 for the entire series. [6] This would seem to close the question but, at the risk of engaging in futile argument, a few final words might be said in support of Marin's date. In view of his lifelong capriciousness in adapting medium and means to his purpose, the similarity of some of the more conservative of the paintings to early works such as *Weehawken Series* (plate 24) dated 1910 and, above all, the artist's admiration for the highly individual James McNeill Whistler, known for having flung a pot of paint in the public's face. (Is there the

slightest possibility that *Weehawken Sequence No. 24* [plate 6] could have been inspired by Whistler's *Nocturne*?) perhaps an earlier date should not be ruled out altogether. Finally, even though the establishment of the later date alters the conceptual significance of these paintings, it does not carry with it the complete negation of their importance, nor does it greatly diminish Marin's contribution.

It was not until 1905, when he was almost thirty-five years old, that Marin went to Paris, and if his purpose in going was to pursue a career of art, he did not go about it with any definite program of study. His long established habits do not seem to have changed much as he drifted about Europe during the next five years. He continued to work, but in his own time on his own terms, developing his strength as an artist slowly but steadily. In later years, the impact of this period too was minimized. In an autobiographical note published in 1922, he would remember it only as a time when he, "...played some billiards, incidentally knocked out some batches of etchings."[7]

John Marin, *Movement, Seine, Paris*, 1909. Watercolor. The Metropolitan Museum of Art, New York, Alfred Stieglitz Collection.

Much has been said about Marin's reliance on Whistler's example in his early prints and watercolors. In his important catalogue raisonné of the artist's graphic work published last year, Carl Zigrosser points out that Marin could have been working in the common idiom resulting from Whistler's universal influence in the field of graphic art.[8] In any case, Marin made brilliant use of this master's delicate works as a point of departure for his own expression. It was not what he found in them but what he didn't find that was so useful to him. The characteristic delicacy of line and subtlety of tone are not shared completely in even the earliest of Marin's etchings; rather it was what Whistler left out, seemingly empty space defining fragmentary form, that struck a chord. From the very beginning Marin was free of the restriction typical of most young artists: the need to fix subject matter with the boundaries of paper or canvas according to a rational logical system obeying the laws of gravity and physical stress in a naturalistic way. By 1909 Whistler's soft veil, through which Marin perceived the world at first, was already being drawn aside to reveal a different kind of view. In *Untitled, No. 1 (Bridge)* (plate 18) and *Movement, Seine, Paris,* his watercolor brush probed into an almost tangible three dimensional space, revealing here and there only those elements essential to the total form. In spite of his insistence that he didn't do much looking at painting during his stay in Europe[9] the New York watercolors of 1910, involving thin washes draped lightly over a skeletal pencil line, invite comparison to Signac but these too contain far more invention than imitation.

John Marin, *Untitled, No. 1 (Bridge)*, 1909. Watercolor. Estate of the Artist, Courtesy of Marlborough Gallery, Inc., New York.

Aside from his work, the most important thing that happened to Marin in Paris during the years abroad was his meeting with the American photographer, Alfred Stieglitz. Stieglitz and his friend Edward Steichen had decided that their Photo-Secession Gallery in New York, known as "291," should complement its exhibition of photography with art which moved beyond photographic means and, well before the famous Armory Show which is supposed to have revolutionized American art, they began to show the works of the avant-garde artists of Europe. Finding Marin's work significantly "anti-photographic," Stieglitz arranged a show for him in 1909 and there began a unique artist-dealer relationship. From their first meeting until Stieglitz's death in 1946, it was a matter of mutual dedication. Placing all financial affairs completely in the hands of his friend, the artist enjoyed absolute freedom to pursue his work. That was all he ever wanted.

Marin returned to America late in 1909, but the following year found him back in Europe. Encouraged and newly motivated by the promise of support, he seemed to work with increased confidence. More convinced of his future as an artist now, perhaps he began to look more deliberately at paintings in Paris; at any rate, works such as *Girl Sewing, Paris* (plate 21) seem to be related to Post-Impressionism. The great series of the watercolors painted in the Tyrol with their limited color and floating intervals of space have a strong Oriental quality which is actually closer to the original source than to Orientalizing Impressionism.

Marin himself gave a fairly accurate estimate of these years abroad:

Some of the etchings I had been making before Stieglitz showed my work already had some freedom about them. I had already begun to let go some. After he began to show my work I let go a lot more, of course. But, in the watercolors I had been making, even before Stieglitz first saw my work, I had already begun to let go in complete freedom.[10]

When he returned to America in 1911, he was prepared to take his place in the forefront of American art.

Back home, Marin was overwhelmed by the phenomenon of New York City. His excitement is conveyed in a letter to Stieglitz (then in Paris) written shortly after his arrival. "I have just started some downtown stuff," he wrote, "and to pile these great houses one upon another with paint as they do pile themselves up there so beautiful, so fantastic — at times one is afraid to look at them but feels like running away."[11] The language is now strictly that of a painter and it is evident that this profound response is due as much to the new vision he had acquired abroad through years of work and practiced looking as to the phenomenon of the city itself.

During the following year, New York was to inspire watercolors which are among the most important works of Marin's career. His subjects were the architectural monuments of the city such as the Woolworth Building, the Municipal Building (plate 28) and the Brooklyn Bridge (plate 34) and his purpose was not to capture their mere visual qualities but to express the basic structural forces pent up within them. His often quoted verbal expression of this effort, paralleling his art to an amazing degree, leaves no doubt as to his motivation.

You cannot create a work of art unless the things you behold respond to something within you. Therefore if these buildings move me they too must have life. Thus the whole city is alive; buildings, people, all are alive; and the more they move me the more I feel them to be alive. It is this 'moving of me' that I try to express, so that I may recall the spell I have been under and behold the expression of the different emotions that have been called into being. How am I to express what I feel so that its expression will bring me back under the spells? Shall I copy facts photographically?

I see great forces at work; great movements; the large buildings and the small buildings; the warring of the great and the small; influences of one mass on another greater or smaller mass. Feelings are aroused which give me the desire to express the reaction of these 'pull forces,' those influences which play with one another; great masses pulling smaller masses, each subject in some degree to the other's power.[12]

The basic concept of these images marks a drastic break with tradition. The idea that physical form must always be a thing apart from the space it occupies is rejected here as the entire format of the painting is activated and structured by expanding fields of force. The broken contour and tilting, irregular planes imply an awareness of contemporary developments of the avant-garde in Europe, particularly Cubism, but in in his detailed analysis of this phase of Marin's art Sheldon Reich cites evidence pointing to an indirect influence of Futurism and Orphism.[13] Perhaps the most direct analogies are to be found in Robert Delaunay's famous views of the Eiffel Tower.

Another artist might have seized upon the innovation of 1912 as a basis for a lifetime of development. Such was not the case with Marin. Though forceful works in this vein continue in the watercolors, drawings, and etchings of 1913 (plate 32), the etchings of 1914 restore a tentative equilibrium to his architectural subjects. At the same time the artist was moving in a new direction, away from the city and toward nature, the inspiration of his youth. Married and settled at Cliffside, New

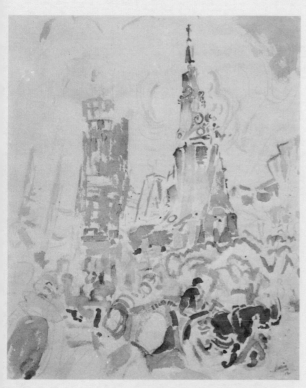

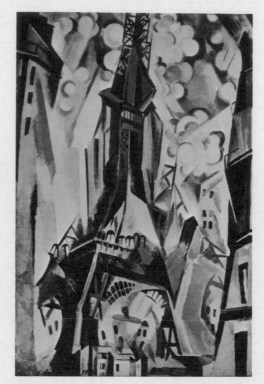

John Marin, *St. Paul's, Lower Manhattan*, 1912. Watercolor. The Wilmington Society of the Fine Arts, Delaware Art Center.

Robert Delaunay, *The Eiffel Tower*, 1910. Oil on canvas, Kunstmuseum, Basel.

Jersey, he began to spend his summers looking for new subject matter. A group of watercolors painted in the woods and fields of Castorland, New York, in 1913 (plate 35) contain little if anything of Cubism and rely on a freely brushed tapestry of bright color. They come as close to Fauvism as Marin was ever to be.

The year 1914 was a crucial year for Marin. It was the year he discovered Maine, and he viewed the dramatic scenery of this place with the same intense emotion he had felt earlier in New York. It was a prolific year and his continued exuberance is expressed in the stream of impressive works that appeared as he worked around West Point and Small Point. The key to these paintings is the quality of brushwork, ranging from an explosive slashing stroke to a more rhythmic, lyrical calligraphy attesting to the artist's spiritual kinship with the Oriental calligrapher (plates 38, 39, 40). The general tendency during these years, however, was one of gradually increasing restraint. It was a time when Marin compared his work to the game of golf. "The fewer strokes I can take," he wrote, "the better the picture."[14]

In the culmination of this phase around 1915-1916 (plates 44, 47) sparse, light-shapes are isolated and defined within an open spatial ambient expressed in terms of bare white paper. Definition is enhanced with an increasing use of the Cubist element in the form of a quasi-geometrical line, sometimes suggesting the use of a stick or brush handle dipped in paint. Paralleling these watercolors is a series of etchings and drawings of the grain elevators at Weehawken (plate 42) which revert to the 1912 New York idiom but in the end become distilled to the point where nothing remains but a few seemingly isolated geometric lines.

The more explosive of these works, particularly those of 1914, have been described as Expressionist and the emergence of Cubistic structure in 1915/16 is clearly apparent. These terms must always be qualified, however, when applied to Marin's style. In fact, his work is always harder to categorize than that of the other participants in the Stieglitz circle of pioneer moderns. Marsden Hartley and Max Weber, in their stark, compelling landscapes and figures, are much nearer Expressionism as such than Marin ever was. The Cubism of Weber and Charles Demuth is more logically related to the idiom as it developed in Paris. In Marin's hands, these two stylistic languages are always transformed, usually with a tendency to blend and balance.

For the most part, the paintings of the Delaware country in Pennsylvania of 1916 (Marin did not return to Maine that summer) retain the style which evolved at Small Point, Maine the previous year, but pictures such as *Cocotte, on Bushkill Creek, Pennsylvania* indicate that the artist was reaching for something else. This

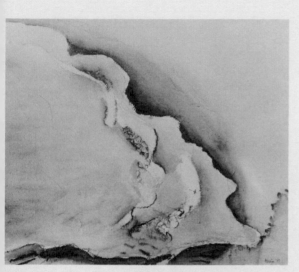

John Marin, *White Waves on Sand, Maine,* 1917. Watercolor. Mr. and Mrs. John Marin, Jr., Foundation, Inc.

Arthur G. Dove, *Waterfall,* 1925. Oil on canvas. The Phillips Collection, Washington, D.C.

search was to continue during the next three years. A few watercolors of 1917 fall completely into the realm of non-objective art, but for an artist who could never accept the basic concept of abstraction, they represent a fruitless essay. In some of the best pictures of this year (plates 50, 51) he has much in common with Arthur Dove, another important artist of the Stieglitz group.[15] While Dove was more objective in extracting design elements from landscape to create an essentially abstract form, he shared Marin's effort to apprehend symbolically the essential forces of nature. The taut, undulating line of *White Waves on Sand,* painted by Marin in 1917, relates perhaps more directly to the organic forms of Dove's later work than to his early abstractions tending toward a more geometric quality.

At Rowe, Massachusetts, the next summer Marin depicted woodlands in pale yellow, green, and blue washes leaving open, negative shapes to activate the format, but some of the pictures (plate 52) rely more directly on Cubist devices. If he complained of "rotten" work by 1919,[16] it was not because he was actually failing, but because he was pushing at the limits of creative power.

In my present mood don't like anything much.
Want to be crazy
Will be crazy
Like to paint some damn fool pictures — no you fool they may be
 foolish but damn foolish?
To paint disorder under a big order.[17]

His state of mind is clearly reflected in the paintings of this year, some of which seem almost reckless in conception and execution. Their most characteristic aspect is a rather loose distribution of large, amorphous shapes of highly saturated color which coincides with subject matter in an almost random fashion (plate 53). Except when these color shapes are modulated by hatching or some kind of linear pattern, the tendency is toward a more two-dimensional effect. A geometrical matrix appearing from time to time (plate 54) has the effect of augmenting, rather than controlling the dynamism of these forms.

For some time now Marin's vision had been occupied to a great extent by woodlands and the essential forces pervading earth, trees, and sky. Architecture was almost forgotten, and the coastal islands of Maine had not yet been fully explored. This was about to change. He stood on the threshhold of the twenties and the creation of some of his greatest works in watercolor that were to deal with these subjects. In a letter to Stieglitz written in 1920 he seems to be forecasting the achievements of the next few years.

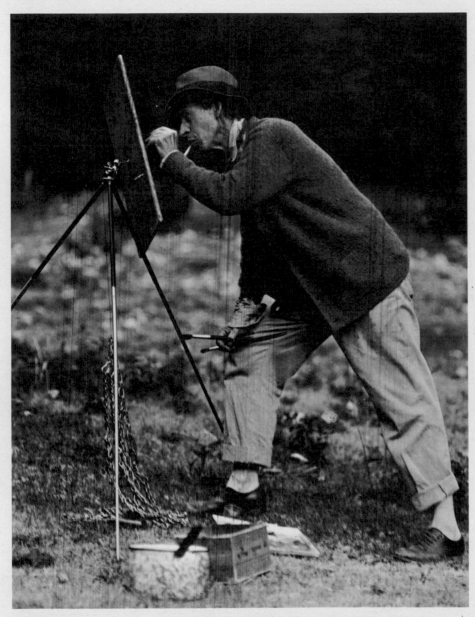

Marin at work in New Mexico, 1930. Photograph by Paul Strand.

I am noticing these village houses more and more this year. Maybe as I grow older I will look with more interest at houses . . . Maybe, having purchased a house, I am kidding myself into an interest in houses. Yes, my chief interests in life, I am strong on houses and islands, the ocean can go nuts. But houses and islands will have my help. Oh, I forgot boats, so

John Marin { *houses*

islands

boats[18]

As late as 1921 the bright loose colors of 1919 recur in such paintings as *Red and Green and Blue — Autumn* (plate 59), but in *Little Church, West Stonington, Deer Isle, Maine* (plate 58) of 1920, the artist builds a solid image in a style establishing the broader handling of Cubist elements seen in the forthcoming New York views. In 1922 he has entered that period of his work in watercolor which may well be called classical. *Maine Islands* and *From Bold Isle* (plate 61) involve a sweep and thrust which brings in the total force of the land, sea, and sky, giving it a firmly structured spatial order. When the artist sets his image apart from the real world by means of an enframement within the painting it serves to intensify the reality he has created. As Marin put it:

. . . my picture must not make one feel that it bursts its boundaries . . .
And too, I am not to be destructive within. I can have things that clash. I can have a jolly good fight going on. There is always a fight going on where there are living things. But I must be able to control this fight at will with a Blessed Equilibrium.
Speaking of destruction, again, I feel that I am not to destroy this flat working surface (that focus plan of expression) that exists for all workers in all mediums. That on my flat plane I can superimpose, build up onto, can poke holes into — By George, I am not to convey the feel that it's bent out of its own individual flatness.[19]

What the artist is getting at here is what his biographer E. M. Benson called his "Near and Far Vision,"[20] and what a German writer refers to as "*Durchblicke*,"[21] a fortunate word meaning a glance through broken, progressive intervals of space. These terms, originally applied to landscapes and seascapes, can be related as well to the New York views of the period. While architectural subject matter demands a somewhat different approach, Marin's basic principles of picture making are operative.

In these watercolors of the twenties, Marin had reached the full capacity of the medium. Like Winslow Homer, he had proved beyond any doubt that it need not be a second rate means of expression. At this point, it was only natural that he would look for some new direction for his work and he found it in the oil medium.

Oil paint was not new to Marin. He had used it with success before, particularly in Castorland in 1913 and in Weehawken in 1916 (plate 48), but in the late twenties and early thirties he begins to manipulate it with more confidence as he described the sea and rising, shifting forms of the city and its inhabitants (plates 92, 98). Though Marin never made full use of the human form as a vehicle of expression, the figures of this period are highly successful. Subordinated within an overall formal language, they function in a very meaningful way. The compartmentalized nudes of *Women Forms and Sea* (plate 96) were to be incorporated in later paintings of the sea.

The thirties see the full emergence of Marin the marine painter. Having discovered Cape Split at Addison, Maine, in 1933, Marin bought a house there which would serve as a summer residence for the rest of his life. Gladly subjecting himself day after day to the infinite moods and movements of the surrounding sea that washed against this rugged Maine shore, he gained a new kind of strength in his work. "Here the sea is so damned insistent," he wrote, "that houses and land things won't appear much in my pictures." His intention was to create ". . . paint wave a breaking on paint shore" [22] and paintings such as *Cape Split, (Composition, Cape Split, Maine)* and *Wave on Rock* (plate 102) demonstrate that he learned to make the oil medium serve his purpose well.

In later works, whether the artist was painting land or sea he still dealt primarily with the essential forces which gave them form. It was his belief that the creative artist should arrange the elements of nature, so that ". . . each takes its place and part in the rhythmic whole — that balanced whole — to sing its music with color, line and spacing upon its keyboard." [23] With his hand moving over the canvas as though he were conducting the music, he knew no restriction. Oliver Larkin said of Marin's watercolors of the twenties that ". . . his mind dictated nothing which his hand could not do . . .". The same can be said of his oil paintings after 1945.

Through the years as Marin worked in both oil and watercolor an interesting qualitative exchange can be noted. The watercolors of the thirties, particularly the depictions of the sea, manifest a distinct change of direction. Dryer and less dependent on the fluency of the medium, they reflect in their more studied configuration a more deliberate approach. It is as though the restriction imposed by the physical working of oil paint had been transferred back to watercolor. Indeed,

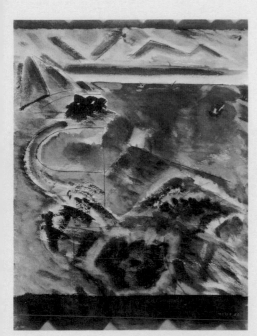
John Marin, *Cape Split, Maine,* 1935. Watercolor. Estate of the Artist, Courtesy of Marlborough Gallery, Inc., New York.

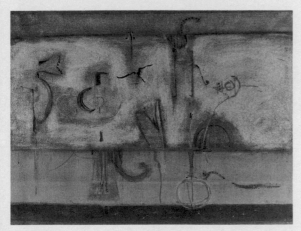
Mark Rothko, *Geologic Reverie,* about 1946. Watercolor and gouache. Los Angeles County Museum of Art, Gift of Mrs. Marion Pike.

the oil paintings of Cape Split soon attain a freedom which is sometimes beyond that of his first medium. As the artist reaches full strength in his oil paintings, watercolor comes apace again gaining a new kind of expressive power, and there is a gradual merging of effects. The numerous sea pieces in both media have such formal similarity that in black and white reproductions a watercolor can easily be mistaken for an oil.

In histories of modern painting Marin is often dismissed after a discussion of the watercolors of the twenties, but more perceptive writers have discovered in the later work many of the elements associated with artists emerging in New York in the forties and fifties. As early as 1947 he said, "Using paint as paint is different from using paint to paint a picture. I'm calling my pictures this year 'Movements in Paint' and not movements of boat, sea, or sky, because in these new paintings, although I use objects, I am representing paint first of all, and not the motif primarily."[24] In spite of the contemporary ring of these words, however, it should be noted that Marin's description in 1940 of ". . . paint wave a breaking on paint shore" says essentially the same thing and his words must be evaluated in the context of his own work. Abstract Expressionism and Surrealism which provided the impetus for its development are the results of cumulative intellectual endeavor, and the fact remains that Marin was not a theoretician. He had no patience with any kind of art that had its origin within the mind without reference to the outside world. As a rule when he attempted to explain his work, he spoke of subject matter and his subjective reaction to it.

Given this fundamental philosophical difference, the great similarity of his painting to that of the Abstract Expressionists is a fact that cannot be denied. The explanation for it is not simple, but there are corresponding factors on both sides which could tend to bring them together. Not the least of these is a minimum degree of preconception in the creative process, combined with a great emphasis on the physical act of painting: the "Ancient Mariner" responding to the forces of the external world as the Expressionist objectifies a state of mind. As early as 1921, in the brilliant *Red and Green and Blue* (plate 59), Marin begins to anticipate the achievements of such artists as Jack Tworkov and Willem de Kooning, and as the pursuit of his "music" intensifies the link between hand and mind, similarities become more apparent. Curiously, some of the watercolors of the thirties (plates 95, 97) with their symbolic line and evocative forms, seem to relate to the earlier Surrealist phase of the movement. By the late forties it is not difficult to find numer-

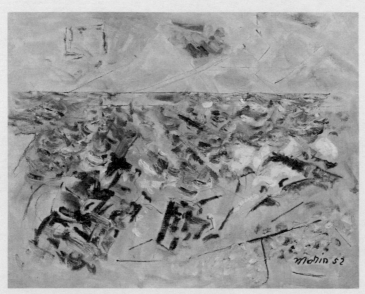

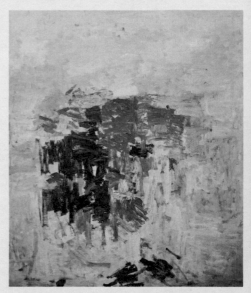

John Marin, *Beach, Flint Island, Maine,* 1952. Oil on canvas. Estate of the Artist, Courtesy Marlborough Gallery, Inc., New York.

Philip Guston, *The Room,* 1954-55. Oil on canvas. Los Angeles County Museum of Art, Contemporary Art Council Fund.

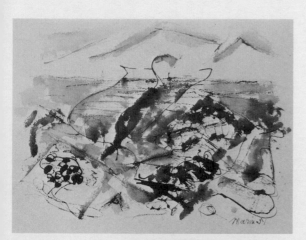
John Marin, *Sea Piece*, 1951. Watercolor. Private Collection.

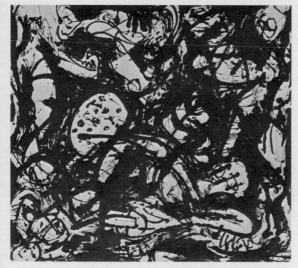
Jackson Pollock, *Black and White Number 20*, 1951. Duco on canvas. Los Angeles County Museum of Art, The Estate of David E. Bright.

ous analogies with the work of Phillip Guston, de Kooning, or even Adolph Gottlieb. The most obvious similarities are to be found in a comparison of the "written" work of the fifties and the painting of Jackson Pollock.

It is easier to evaluate Marin's work than the man himself and his position in the history of modern art. His important role during the early phase of modernism during the second decade of this century was acknowledged from the beginning, but in spite of the rapid growth of his reputation, the second great contribution, that of the late oils, has not been thoroughly understood by the public nor was it exploited to any great extent by younger artists. This is due, at least in part, to the rise of Surrealism in this country which tended to overshadow Marin's accomplishment at a crucial period, and his lack of participation in the artistic community of those who were creating Abstract Expressionism. Already in his seventies, the artist certainly did not need intellectual stimulation to produce his late "Movements in Paint"; moreover, it was always his basic conviction that work was more important than talk. A statement he made in 1928 sums up his life as an artist and clearly defines the motivation which brought him close to succeeding generations:

> There will be the big quiet forms. There will be all sorts of movement and rhythm beats, one-two-three, two-two-three, three-one-one, all sorts, all seen and expressed in color weights. For color is life, the life Sun ashining on our World revealing in color light all things.
> In the seethe of this, in the interest of this, in the doing of this, terms, abstract, concrete, third or fourth dimension—bah. Don't bother us.
> For the worker, the seer, is apt to damn all terms applied by the discussionists. But the glorious thing is that we cannot do, elementally do, other than our ancestors did. That is, that round conveys to all who see it as a similar definite, a triangle a similar definite, solids of certain forms similar definites, that a line— what I am driving at is that a round remains, a triangle remains, a line remains and always was.
> So that the worker of today, as of old picks up each of these things with recognition. And as to color, we pick out red today as the old Chinaman did. And as for race language of color, all races of all times, I am sure, have had color language otherwise they are as dead people. And it's all similar elementally.[25]

This stands as the creed of an artist who found a way to make the elements of design function synonymously with the universal, elemental forces of the world which sustain and direct life itself.

Larry Curry
Curator of American Art

PLATES

1] WHITE LAKE, SULLIVAN COUNTY, NEW
YORK, No. 1, 1888
Watercolor, 8¾ x 11¾
Mr. and Mrs. John Marin, Jr., New York
(Illustrated)

2] EDGEWATER ON HUDSON, NEW JERSEY,
1893
Watercolor, 7 x 10
Estate of the Artist, Courtesy of
Marlborough Gallery, Inc., New York

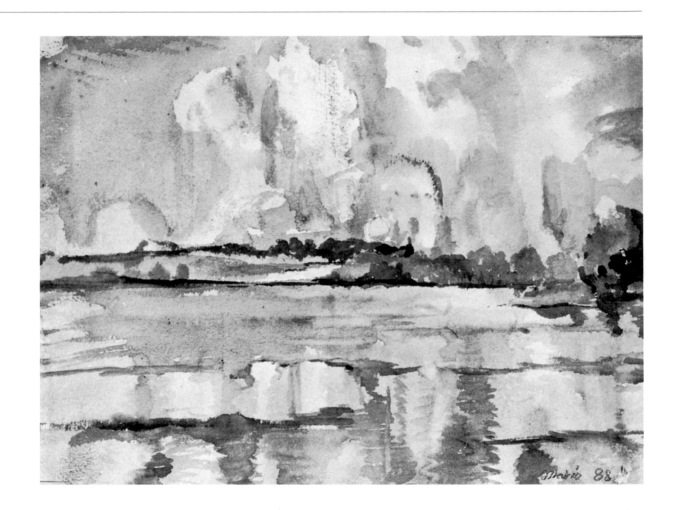

3] OLD TOWN HALL TOWER, PHILADELPHIA, about 1898
Pencil, 10¾ x 8½
Private Collection

4] TWO STUDIES — HIGH BRIDGE — ALONG HARLEM RIVER, 1898
Pen and ink, 6½ x 16
Private Collection

5] WEEHAWKEN SEQUENCE, 1903-04(?)
Oil on canvas board, 12 x 10
Private Collection
(Illustrated)

6] WEEHAWKEN SEQUENCE, No. 24, 1903-04(?)
Oil on canvas board, 12¼ x 9½
Estate of the Artist, Courtesy of Marlborough Gallery, Inc., New York

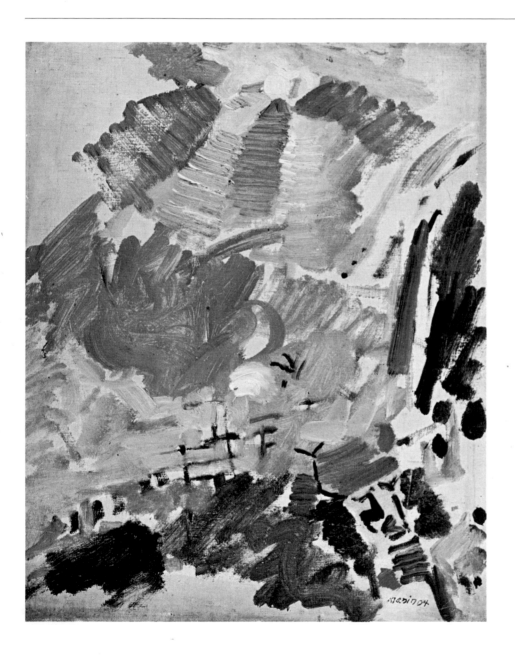

7] WEEHAWKEN SEQUENCE, No. 41,
1903-04(?)
Oil on canvas board, 9½ x 12¼
Estate of the Artist, Courtesy of
Marlborough Gallery, Inc., New York

10] NEW YORK AND RIVER FROM
WEEHAWKEN HEIGHTS, 1904
Pencil, 5½ x 8½
Private Collection

8] WEEHAWKEN SEQUENCE, No. 53, 1903-04(?)
Oil on canvas board, 8⅞ x 11⅞
Estate of the Artist, Courtesy of
Marlborough Gallery, Inc., New York

9] WEEHAWKEN SEQUENCE, No. 56,
1903-04(?)
Oil on canvas board, 9 x 12
Estate of the Artist, Courtesy of
Marlborough Gallery, Inc., New York
(Illustrated)

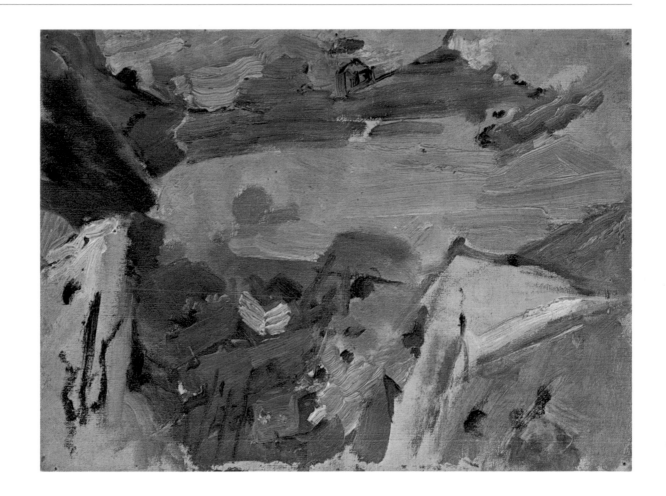

11] A STREET—WEST NEW YORK, 1905
Pencil, 7 x 10¼
Estate of the Artist, Courtesy of
Marlborough Gallery, Inc., New York

12] LONDON — ATLANTIC SERIES, 1905
Pen and ink, 6½ x 5
Private Collection

13] UNTITLED (MOVEMENT, PARIS), 1905
Pastel, 11¼ x 14⅛
Private Collection

14] UNTITLED (PARIS SCENE), 1905
Pastel, 9 x 11½
Private Collection
(Illustrated)

15] RUE MOUFFETARD, PARIS, 1906
Etching, 9 x 6¾ (Zigrosser, No. 30)
Philadelphia Museum of Art, Staunton B. Peck
Fund, from the Carl and Laura Zigrosser
Collection

16] PALAZZO DARIO, VENICE, 1907
Etching, 7⅞ x 5½ (Zigrosser, No. 67)
Philadelphia Museum of Art, J. Wolfe Golden
and Celeste Golden Collection of Marin
Etchings

17] NOTRE DAME, PARIS, 1908
Etching, 12⅞ x 10¾ (Zigrosser, No. 79 v/v)
Philadelphia Museum of Art, J. Wolfe Golden
and Celeste Golden Collection of Marin
Etchings

18] UNTITLED, No. 1 (BRIDGE), 1909
Watercolor, 13¼ x 16
Private Collection
(Illustrated)

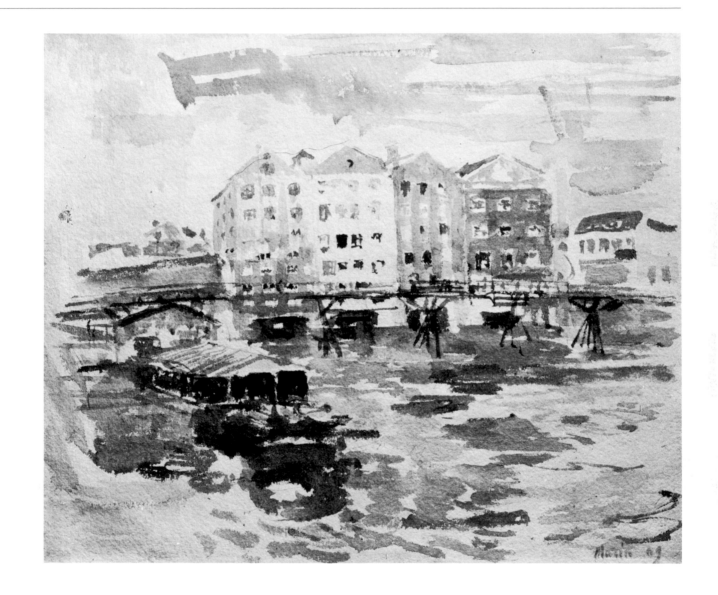

19] MOVEMENT, SEINE, PARIS, 1909
Watercolor, 13⅜ x 16⅛
The Metropolitan Museum of Art, New York,
Alfred Stieglitz Collection

20] NEAR THE QUAI DES ORFEVRES, PARIS,
1909
Etching, 7⁷⁄₁₆ x 8⅜ (Zigrosser, No. 98)
Philadelphia Museum of Art,
J. Wolfe Golden and Celeste Golden Collection
of Marin Etchings

21] GIRL SEWING, PARIS, 1910
Watercolor, 18½ x 15¼
Private Collection
(Illustrated)

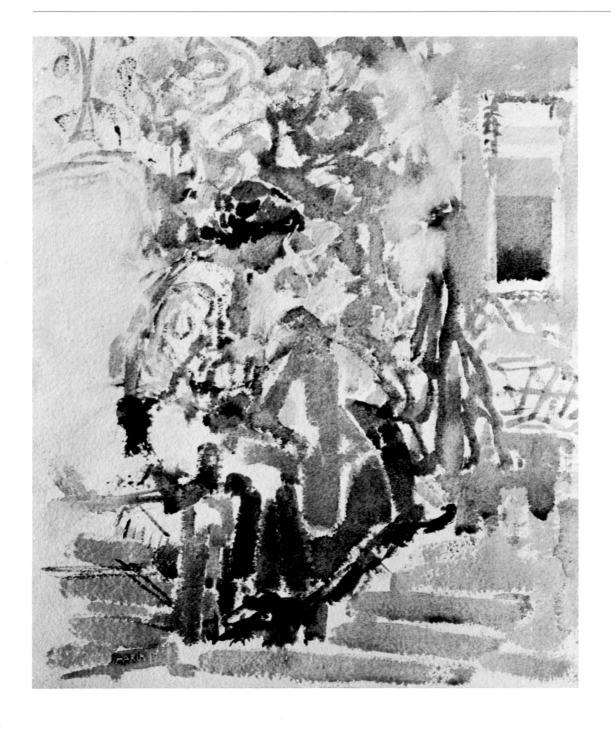

22] KUFSTEIN, AUSTRIAN TYROL, 1910
Watercolor, 15½ x 18
Mr. and Mrs. John Marin, Jr., New York
(Illustrated)

25] UNTITLED (UNDER BROOKLYN BRIDGE),
1910
Watercolor, 14 x 17¼
Private Collection

23] WALL STREET, 1910
Pencil, 11¼ x 8
Private Collection

24] WEEHAWKEN SERIES, 1910
Watercolor, 16⅛ x 13⅜ (sight)
The Metropolitan Museum of Art, New York, Alfred
Stieglitz Collection

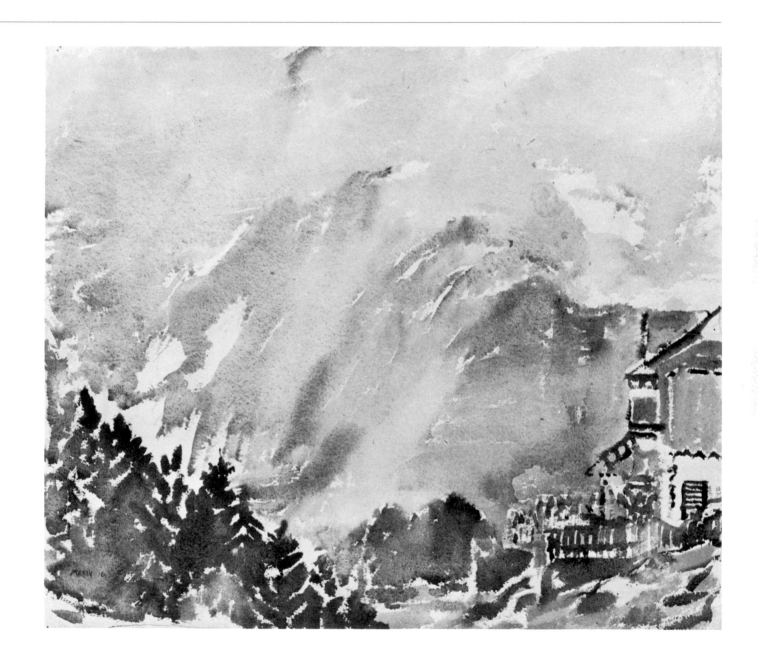

26] FULTON CHAIN, ADIRONDACKS, 1912
Watercolor, 13¾ x 16¼
Private Collection

27] WOOLWORTH BUILDING IN
CONSTRUCTION, about 1912
Pencil, 10 x 8
Private Collection

28] MUNICIPAL BUILDING—NEW YORK,
1912
Watercolor, 18½ x 15⅝ (sight)
Philadelphia Museum of Art, Philadelphia,
Pennsylvania, A. E. Gallatin Collection
(Illustrated)

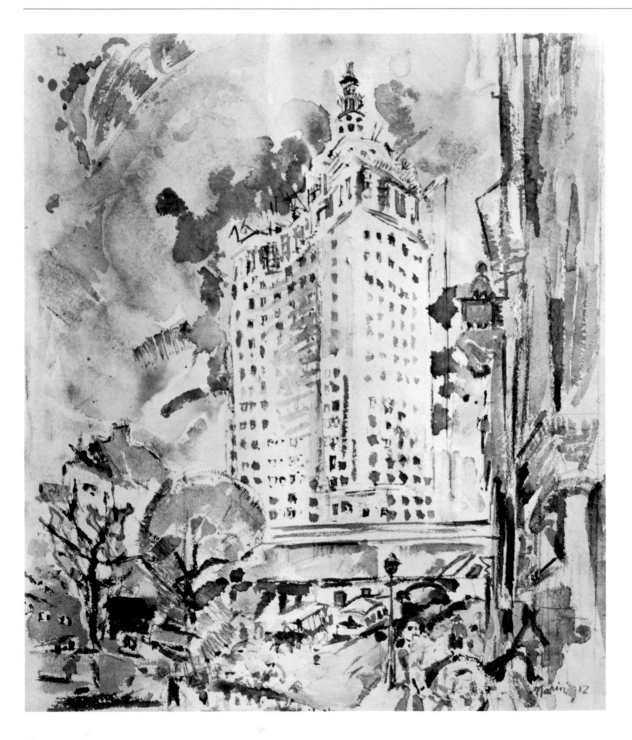

29] ST PAUL'S, LOWER MANHATTAN, 1912
Watercolor, 18 x 14
The Wilmington Society of the Fine Arts,
Delaware Art·Center

30] BROOKLYN BRIDGE, about 1912
Watercolor, 18½ x 15½
The Metropolitan Museum of Art, New York,
Alfred Stieglitz Collection
(Illustrated)

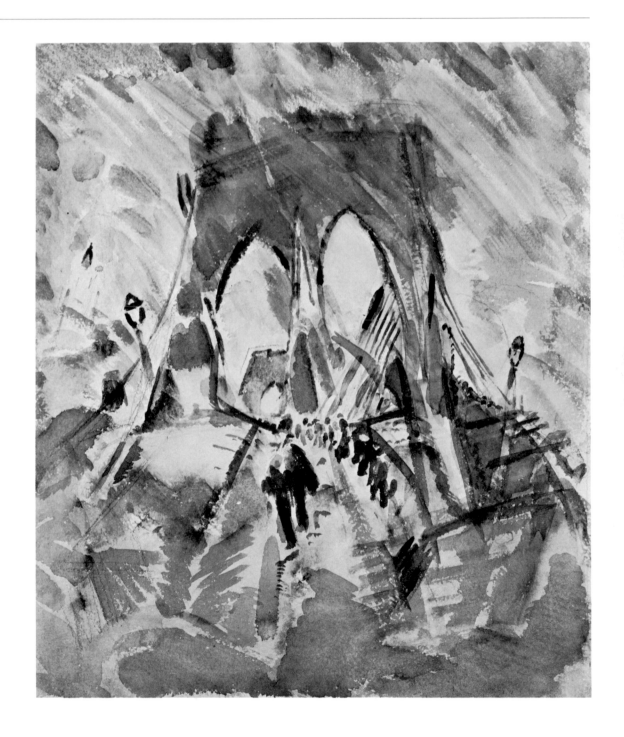

31] BROOKLYN BRIDGE (Mosaic), 1913
Etching, 11½ x 9 (Zigrosser, No. 107 ii/ii)
Philadelphia Museum of Art, Philadelphia,
Pennsylvania, Alfred Stieglitz Collection

32] FROM BROOKLYN BRIDGE, 1913
Watercolor, 15½ x 18½
Private Collection
(Illustrated)

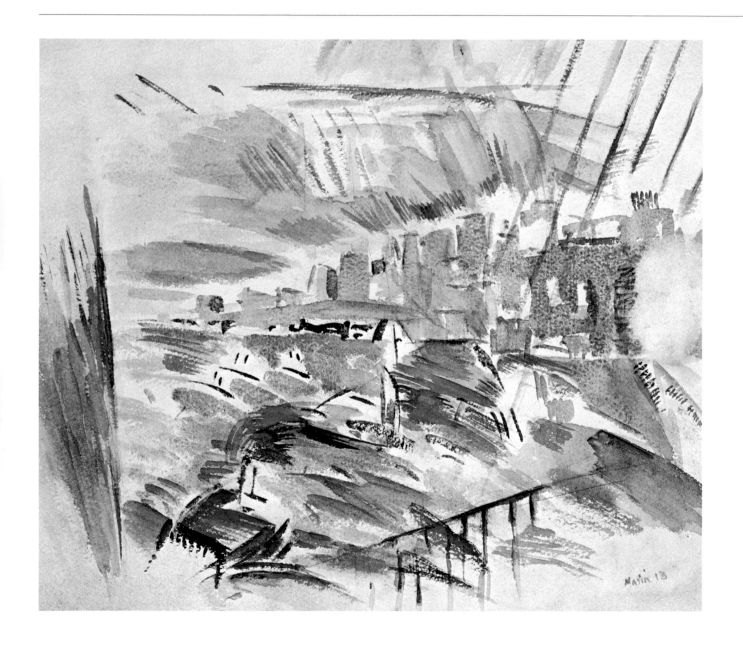

33] WOOLWORTH BUILDING, No. 2, 1913
Etching, 13 x 10½ (Zigrosser, No. 114 ii/ii)
Philadelphia Museum of Art, Staunton B. Peck
Fund, from the Carl and Laura Zigrosser
Collection

34] WOOLWORTH BUILDING (THE DANCE),
1913
Etching, 13 x 10½ (Zigrosser, 116 ii/ii)
Philadelphia Museum of Art, Philadelphia,
Pennsylvania, Alfred Stieglitz Collection

35] WOOD INTERIOR, CASTORLAND, NEW
YORK, 1913
Watercolor, 18¾ x 16
Estate of the Artist, Courtesy of Marlborough
Gallery, Inc., New York
(Illustrated)

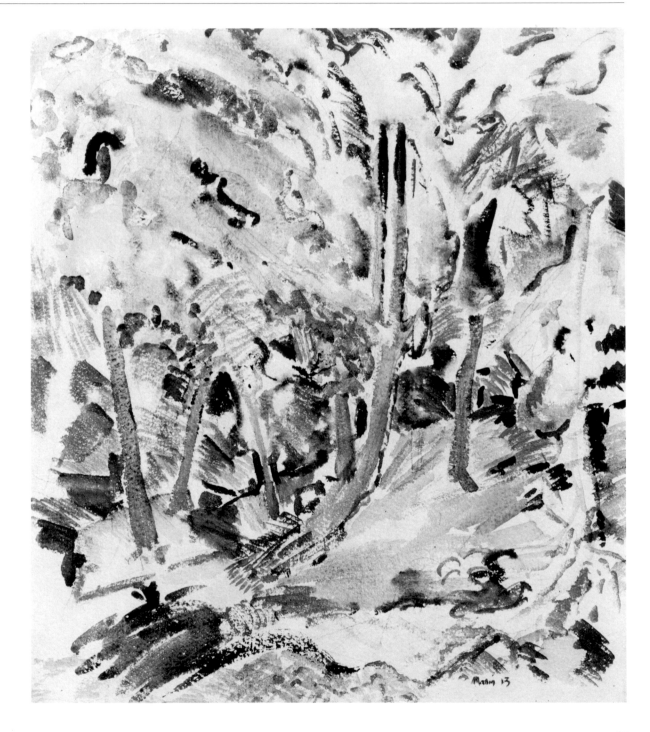

36] CASTORLAND, NEW YORK, 1913
Watercolor, 15 x 17
Dr. and Mrs. Harold Rifkin, Riverdale,
New York

37] EDGEWATER, NEW JERSEY, 1913
Watercolor, 14 x 16
Mr. and Mrs. John Marin, Jr., New York
(Illustrated)

38] SPRUCE WITH MOSS, SMALL POINT,
MAINE, 1914
Watercolor, 19¼ x 16³⁄₁₆ (sight)
Private Collection

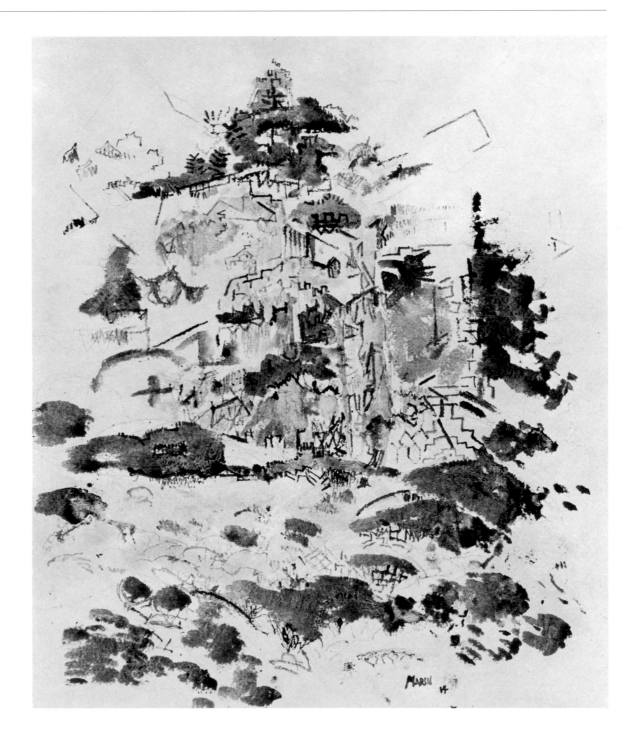

39] WEST POINT, MAINE, 1914
Watercolor, 19⅝ x 16½
Private Collection

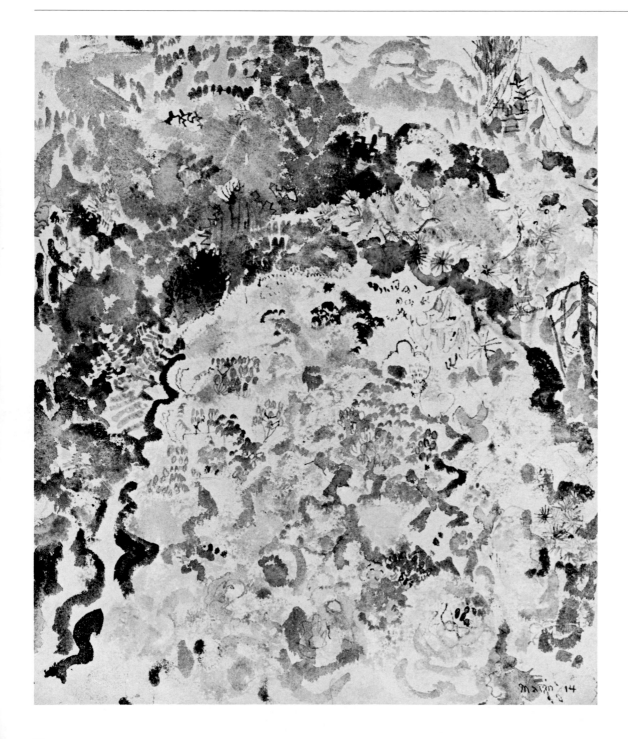

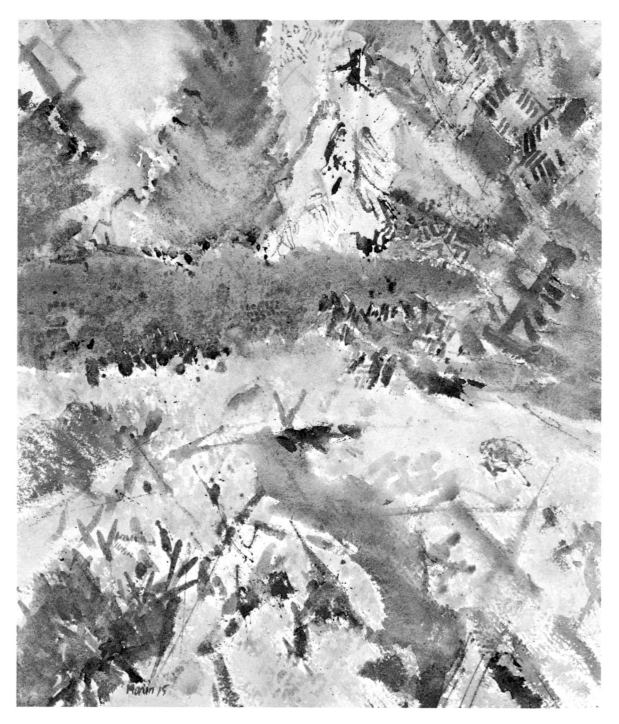

41] GRAIN ELEVATOR, WEEHAWKEN, 1915
Etching, 11¼ x 9¹/₁₆ (Zigrosser, No. 125)
Philadelphia Museum of Art, J. Wolfe Golden
and Celeste Golden Collection of Marin
Etchings

42] UNTITLED (WEEHAWKEN GRAIN
ELEVATOR), about 1915
Pencil, 10½ x 8 (sight)
Private Collection
(Illustrated)

43] UNTITLED (GRAIN ELEVATORS,
WEEHAWKEN, NEW JERSEY), about 1915
Pencil, 8½ x 11
Estate of the Artist, Courtesy of
Marlborough Gallery, Inc., New York

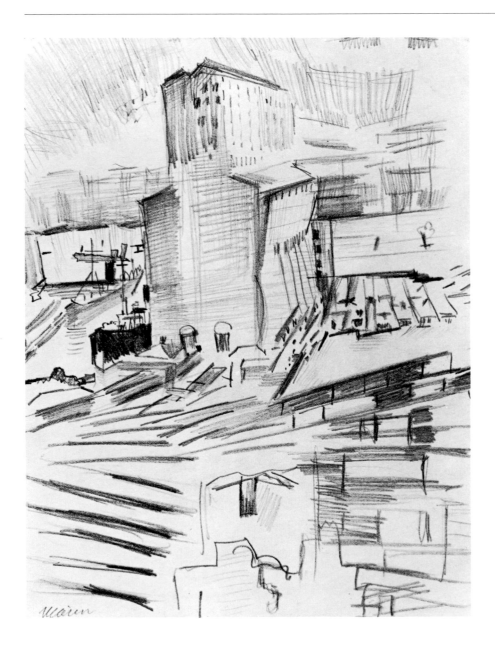

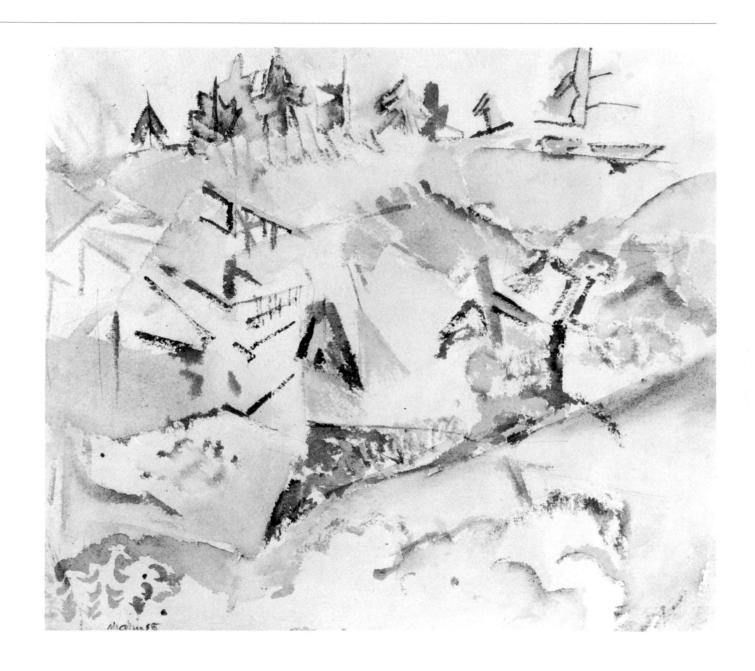

45] PORTRAIT OF JOHN, JR., 1915
Watercolor, 16¼ x 14
Lisa Marie Marin, New York

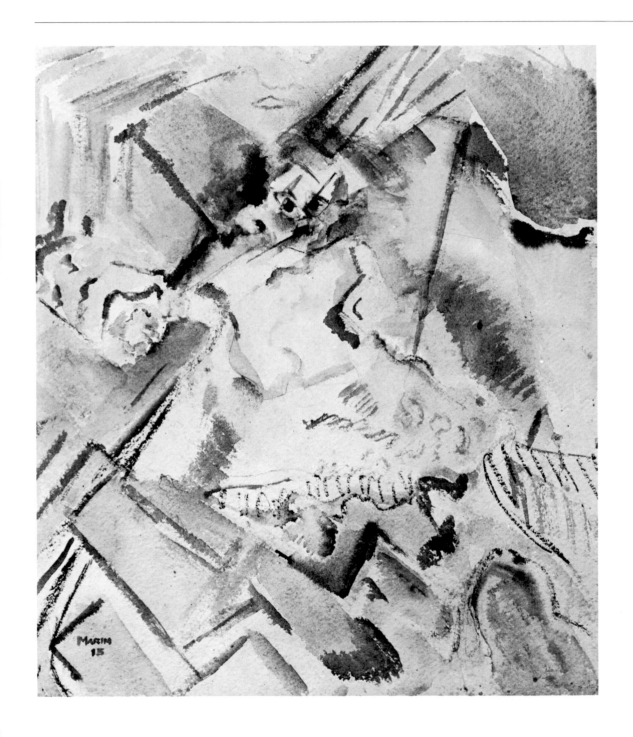

46] LANDSCAPE ABSTRACTED, 1916
Watercolor, 14¾ x 18
Mr. and Mrs. William L. McLennan, Lake
Forest, Illinois

47] DELAWARE COUNTRY, PENNSYLVANIA,
1916
Watercolor, 19¼ x 16
Private Collection
(Illustrated)

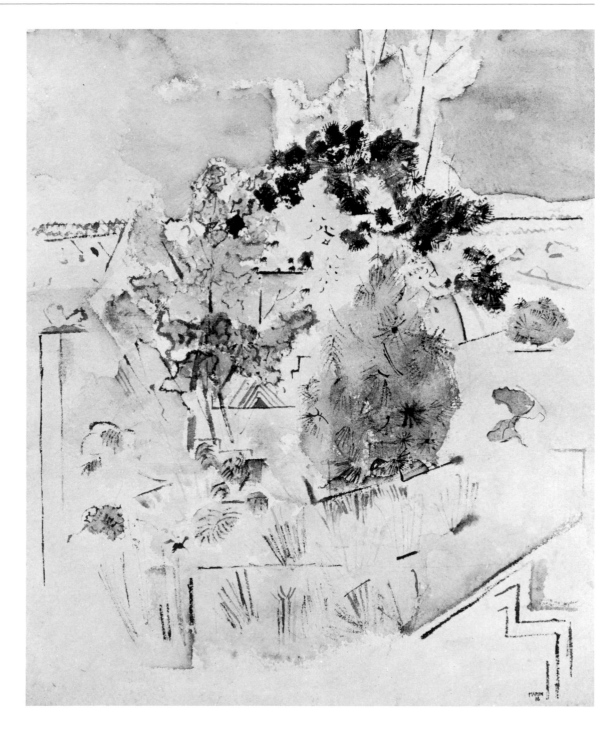

48] WEEHAWKEN GRAIN ELEVATORS, 1916
Oil on canvas, 19¼ x 23¼
Estate of the Artist, Courtesy of
Marlborough Gallery, Inc., New York

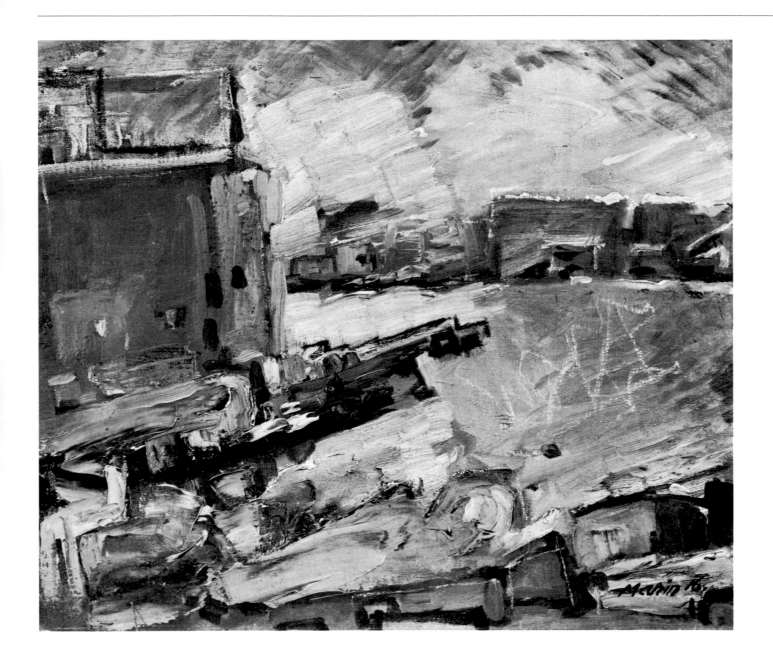

49] COCOTTE, ON BUSHKILL CREEK,
PENNSYLVANIA, 1916
Watercolor, 16½ x 19¼
Estate of the Artist, Courtesy of
Marlborough Gallery, Inc., New York

50] WHITE WAVES ON SAND, MAINE, 1917
Watercolor, 16 x 18½
Mr. and Mrs. John Marin Jr. Foundation, Inc.,
New York
(Illustrated)

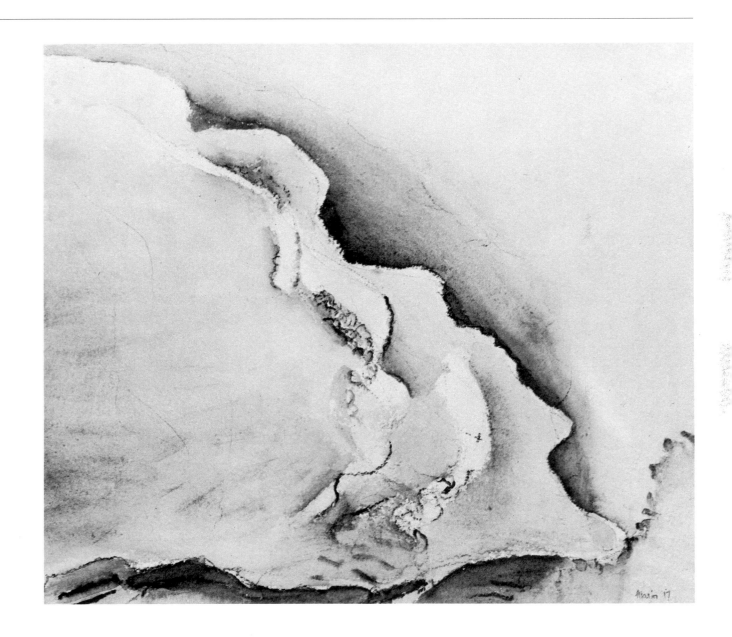

51] ROWE, MASSACHUSETTS, 1918
Watercolor, 16¼ x 19¾
Private Collection

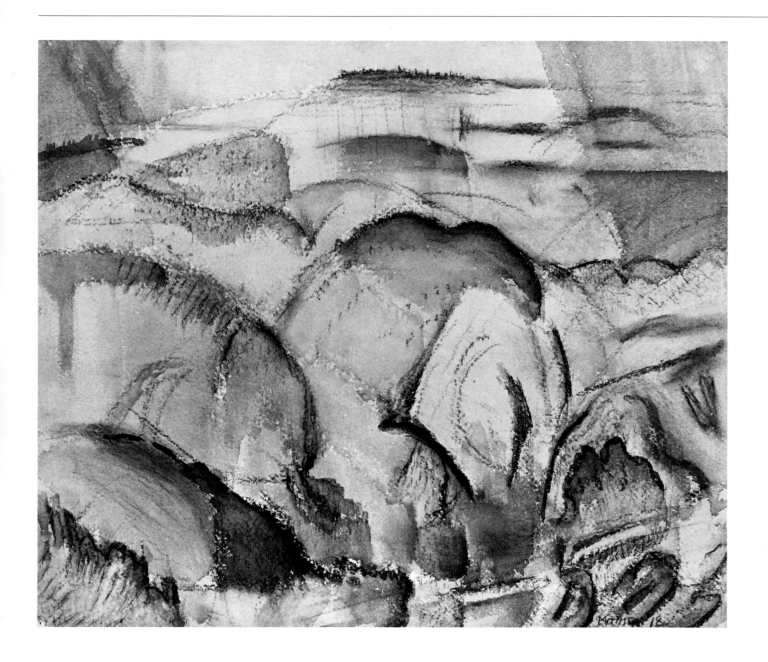

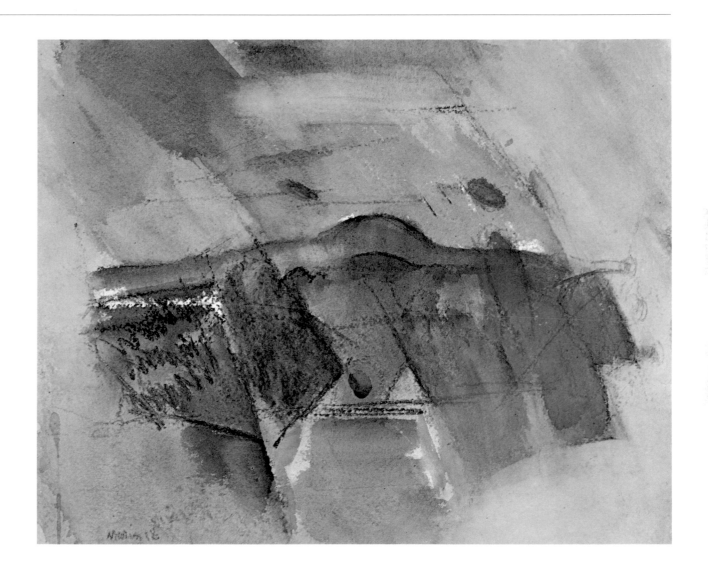

53] DEER ISLE, MAINE, 1919
Watercolor, 13¾ x 16⅝
Private Collection

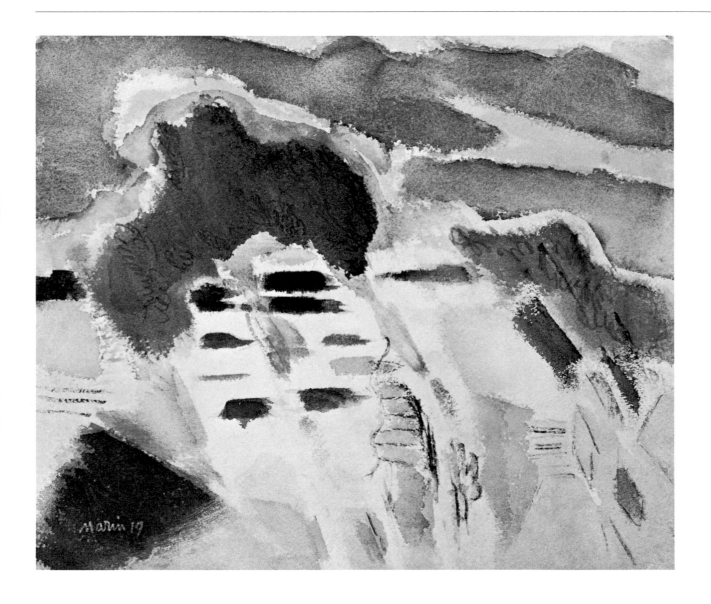

54] TREE FORMS, STONINGTON, MAINE,
1919
Watercolor, 16½ x 13⅜ (sight)
The Metropolitan Museum of Art, New York,
Alfred Stieglitz Collection
(Illustrated)

55] UNTITLED (FIGURES AND BUILDINGS,
NEW YORK CITY), about 1919
Pencil, 8½ x 16 ¹¹/₁₆
Estate of the Artist, Courtesy of
Marlborough Gallery, Inc., New York

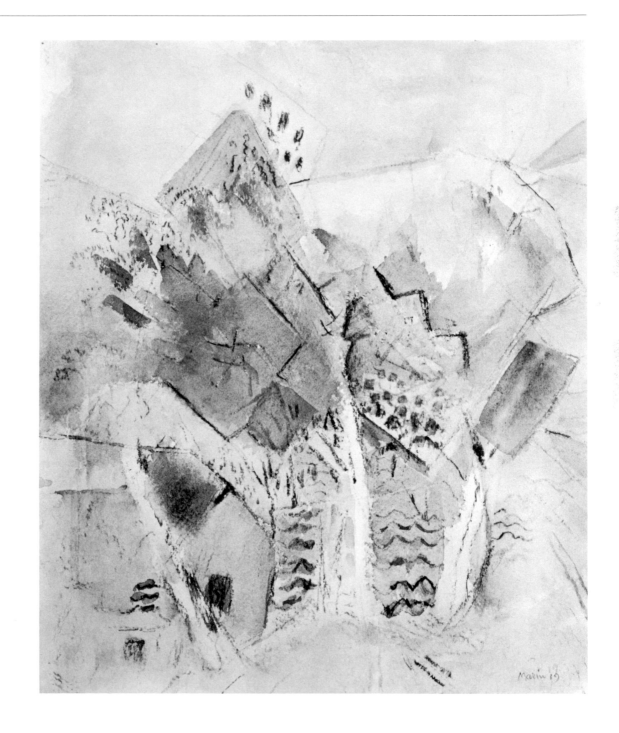

56] MOTT STREET, 1920's
Colored pencil, 10 x 8
Private Collection

57] UNTITLED (MUNICIPAL BUILDING,
DOWNTOWN NEW YORK), about 1920
Pencil, 10 x 8
Private Collection

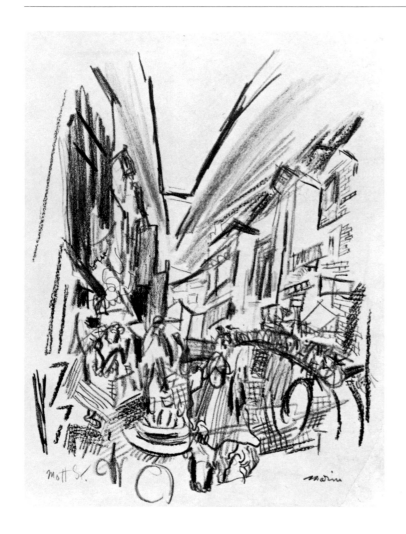

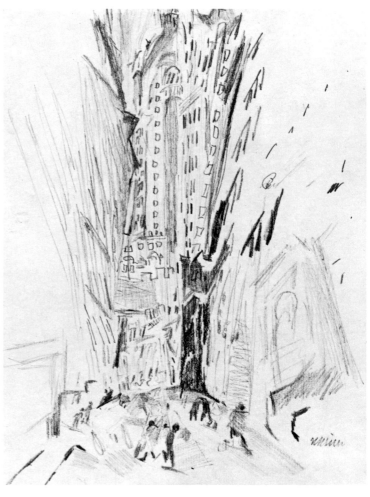

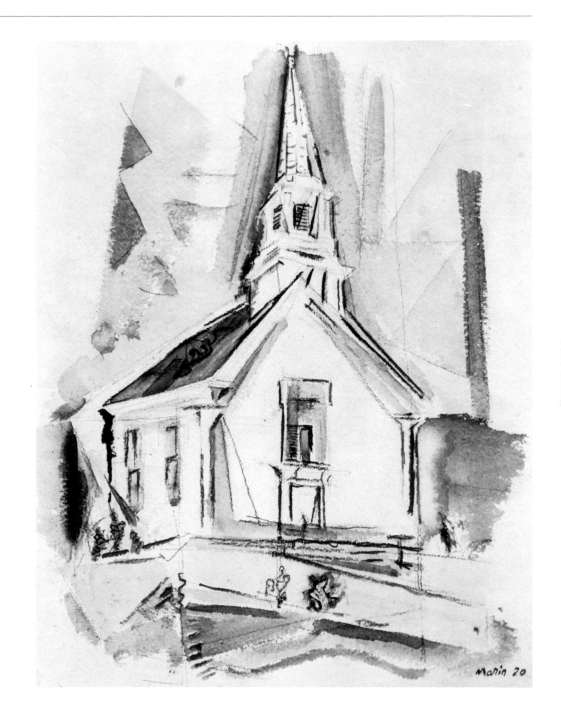

59] RED AND GREEN AND BLUE—AUTUMN,
1921
Watercolor, 19½ x 16
Private Collection

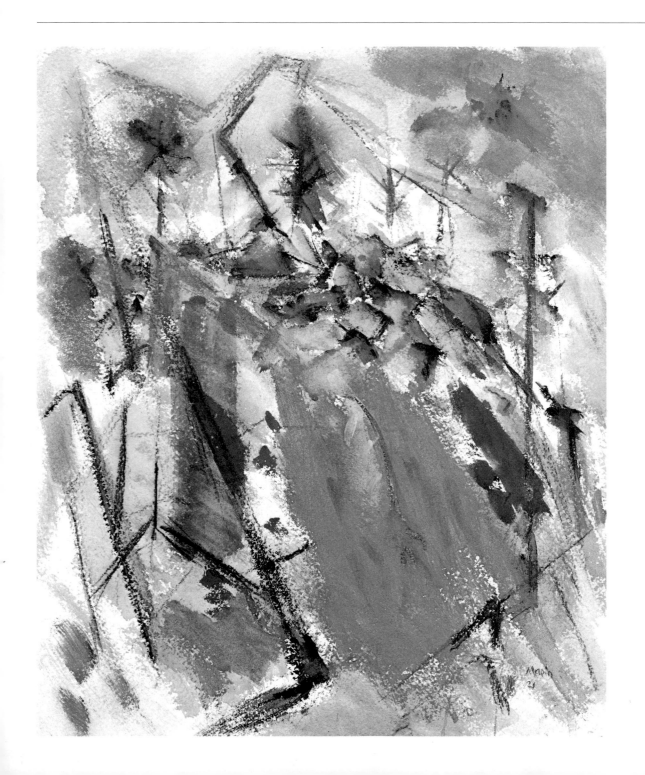

60] MAINE ISLANDS, 1922
Watercolor, 16¾ x 20
The Phillips Collection, Washington, D.C.

61] FROM BOLD ISLE, MAINE, 1922
Watercolor, 17⅜ x 20¼
Private Collection
(Illustrated)

62] LOWER MANHATTAN (COMPOSING
DERIVED FROM TOP OF WOOLWORTH), 1922
Watercolor, 21⅝ x 26⅞
Museum of Modern Art, New York, acquired
through the Lillie P. Bliss Bequest

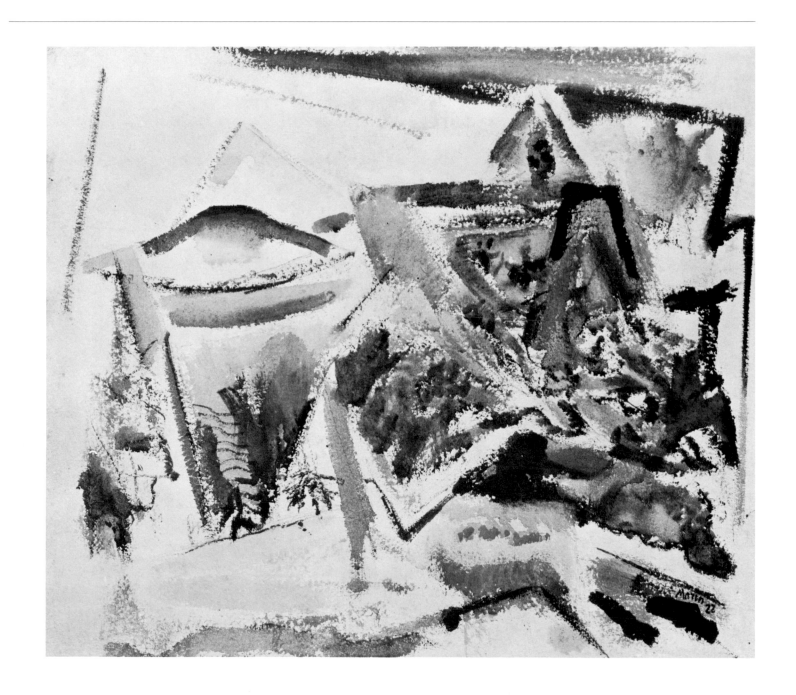

63] RED SUN, BROOKLYN BRIDGE, 1922
Watercolor, 21 3/8 x 26 3/16
Art Institute of Chicago, Chicago, Illinois,
Alfred Stieglitz Collection
(Illustrated)

64] BELLOWS FALLS, VERMONT, 1923
Pencil and colored pencil, 8½ x 10 13/16
Private Collection

65] UNTITLED (FLATIRON BUILDING, NEW
YORK CITY), about 1924
Colored pencil, 9 13/16 x 7 7/8
Private Collection

66] WEST STREET (NEW YORK CITY), about 1924
Pencil and crayon, 7 13/16 x 9 13/16
Estate of the Artist, Courtesy of
Marlborough Gallery, Inc., New York

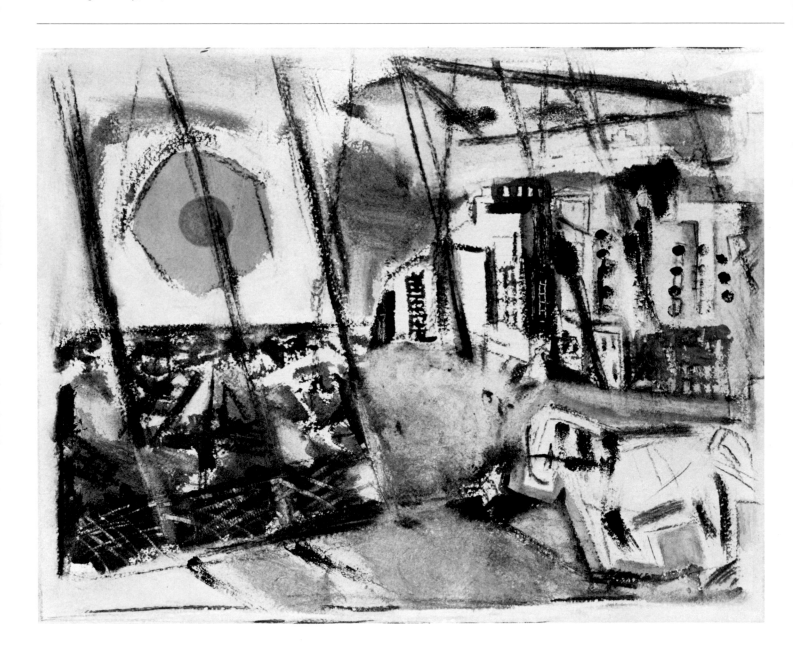

67] NASSAU STREET, LOOKING SOUTH, 1924
Etching, 8 x 6 (Zigrosser, No. 135)
Philadelphia Museum of Art, J. Wolfe Golden
and Celeste Golden Collection of Marin
Etchings

68] SCHOONER AND SEA, MAINE, 1924
Watercolor, 16⅜ x 19⅝
Mrs. Dorothy Norman, New York

69] DOWNTOWN NEW YORK, TELEPHONE
BUILDING, about 1925
Watercolor, 21¾ x 26
Private Collection
(Illustrated)

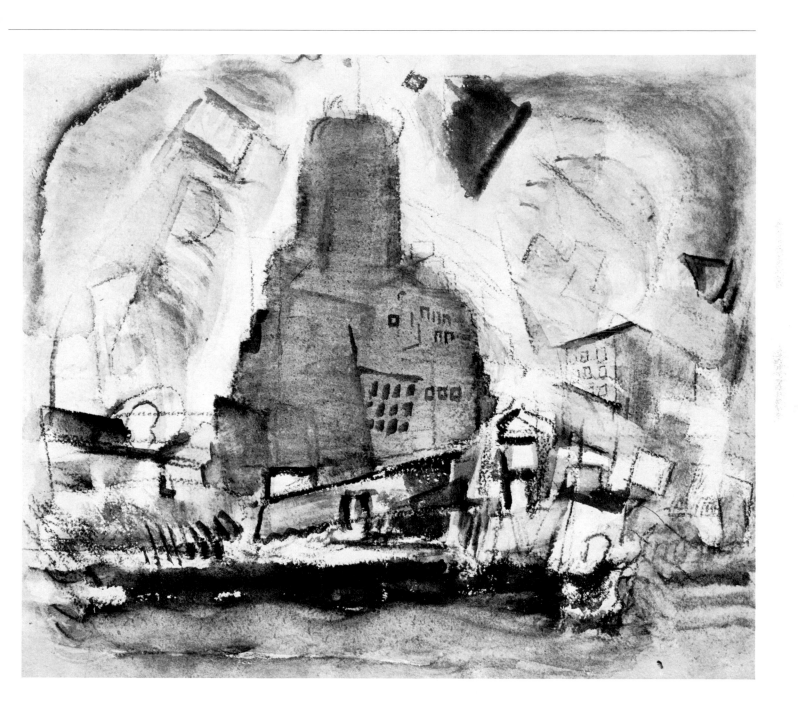

70] UNTITLED (BROOKLYN BRIDGE), about
1925
Pencil, 7½ x 9⅞
Private Collection

71] DEER ISLE, MAINE, MOVEMENT No. 23,
THE SEA AND PERTAINING THERETO, 1927
Watercolor, 16¾ x 21
Lisa Marie Marin, New York

72] DEER ISLE, MAINE — BOAT AND SEA, 1927
Watercolor, 13 x 17
Philadelphia Museum of Art, Samuel S. White
III and Vera White Collection

73] MOVEMENT IN BROWN WITH SUN, 1928
Oil on canvas, 22 x 27
Andrew J. Crispo, New York
(Illustrated)

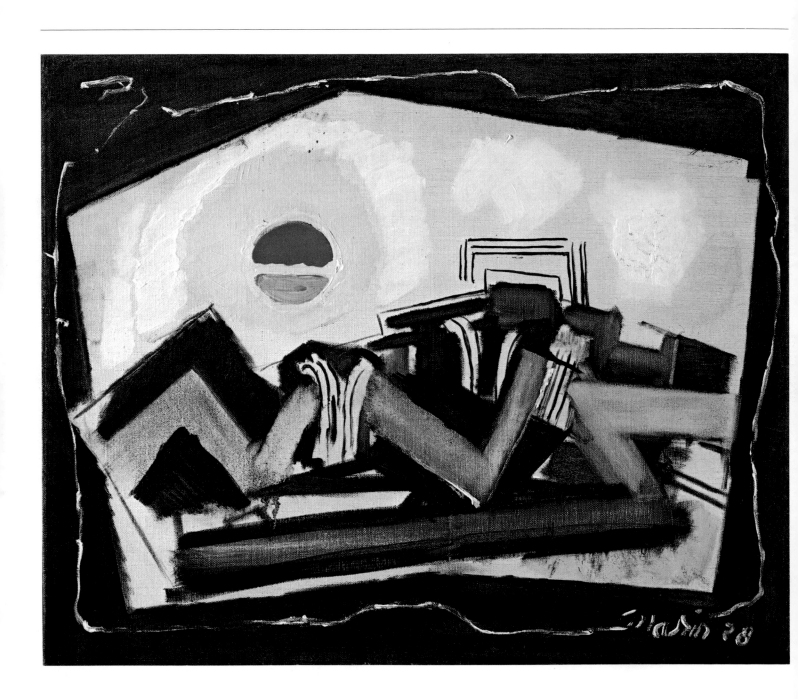

74] MARK ISLE AND BAY, DEER ISLE, MAINE, 1928
Watercolor, 12½ x 16
Mr. and Mrs. Harry M. Goldblatt, New York
(Illustrated)

75] BOAT FANTASY, DEER ISLE, MAINE, No. 30, 1928
Watercolor, 17¾ x 23
Andrew J. Crispo, New York

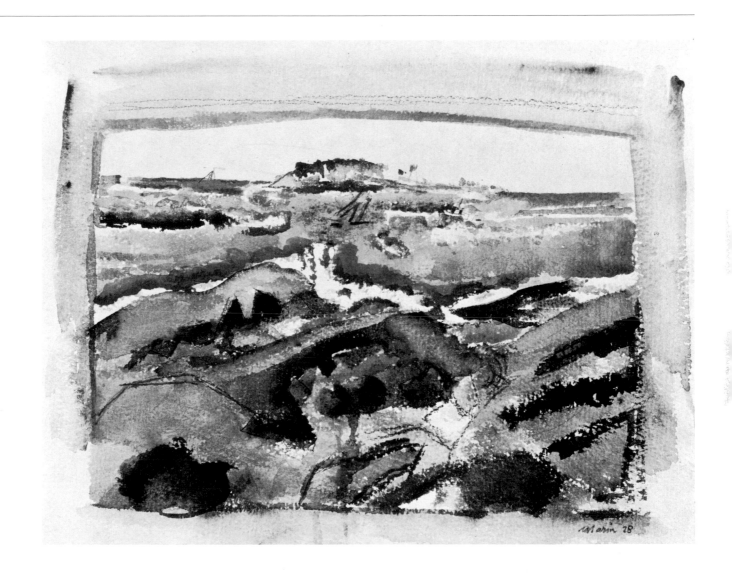

76] SUN AND GREY SEA, SMALL POINT, MAINE,
SERIES No. 16, 1928
Watercolor, 14⅜ x 16¹⁵⁄₁₆
The Metropolitan Museum of Art, New York
Alfred Stieglitz Collection

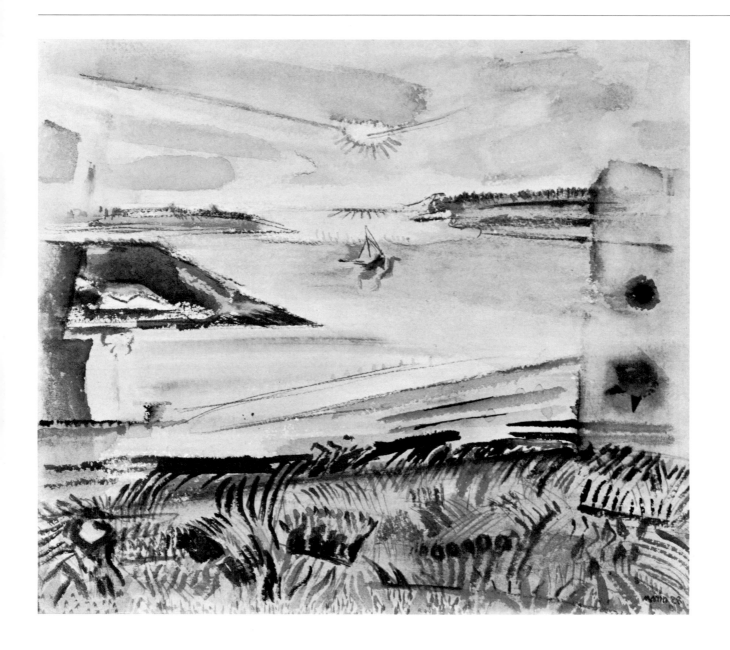

77] RELATED TO ST. PAUL'S, NEW YORK, 1928
Oil on canvas, 26½ x 30
Private Collection
(Illustrated)

78] UNION HILL, NEW JERSEY, 1929
Oil on canvas, 27 x 21
Estate of the Artist, Courtesy of
Marlborough Gallery, Inc., New York

79] DANCE OF THE PUEBLO INDIANS, 1929
Watercolor, 21½ x 28⅜
Private Collection

80] ST PAUL'S AGAINST THE EL, 1930
Etching, 9¾ x 7 (Zigrosser, No. 146)
Philadelphia Museum of Art, Staunton B. Peck Fund,
from the Carl and Laura Zigrosser Collection

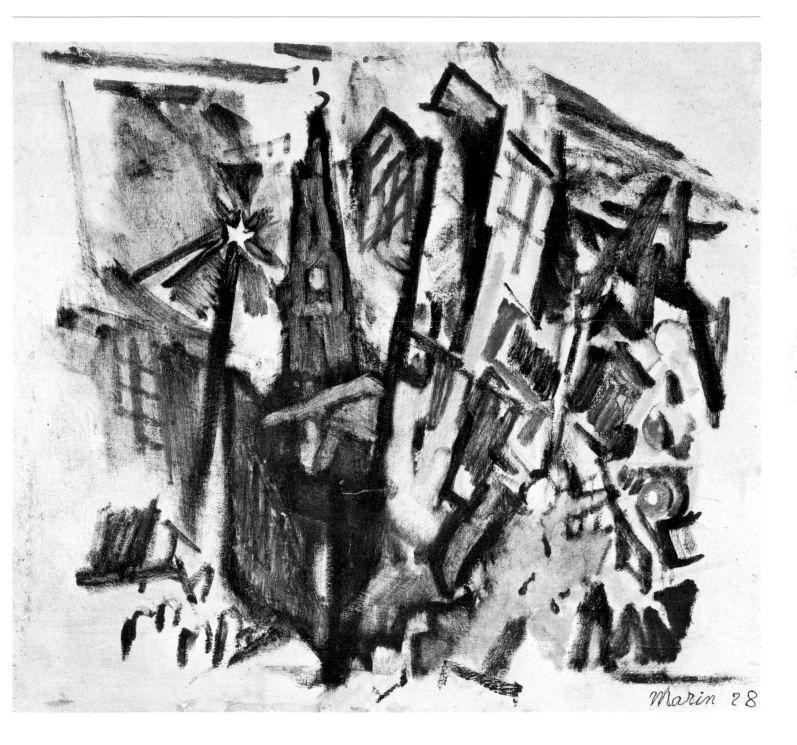

81] CANYON OF THE HONDO, NEW MEXICO, 1930
Watercolor, 15⅜ x 20¼
Estate of the Artist, Courtesy of
Marlborough Gallery, Inc., New York
(Illustrated)

82] CHICAGO, 1930
Colored pencil, 9⅝ x 7⅝
Private Collection

83] STREET MOVEMENT, ABSTRACTION,
NEW YORK, 1931
Watercolor 18 x 21⅝ (sight)
Dr. and Mrs. Irving Levitt, Southfield, Michigan

84] LOWER MANHATTAN FROM THE TIP END,
1931
Oil on canvas, 22 x 27
Private Collection

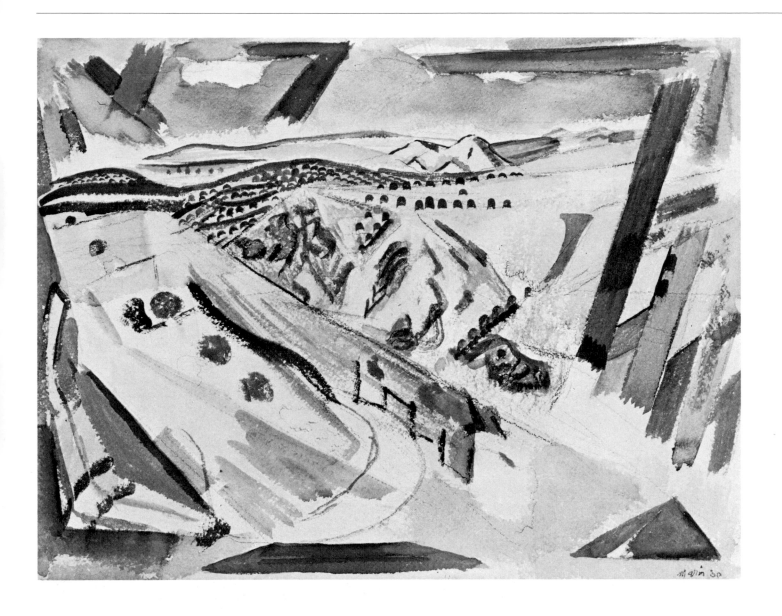

85] FIGURES IN A WAITING ROOM, 1931
Oil on canvas, 22 x 27
Estate of the Artist, Courtesy of
Marlborough Gallery, Inc., New York

86] BRYANT SQUARE, NEW YORK CITY, 1931
Pencil, 11½ x 14 11/16
Estate of the Artist, Courtesy of
Marlborough Gallery, Inc., New York

87] SMALL POINT, MAINE, 1931
Watercolor, 16¾ x 22¼
Andrew J. Crispo, New York

88] ROCKS AND SEA, 1932
Oil on canvas, 22 x 28
Private Collection
(Illustrated)

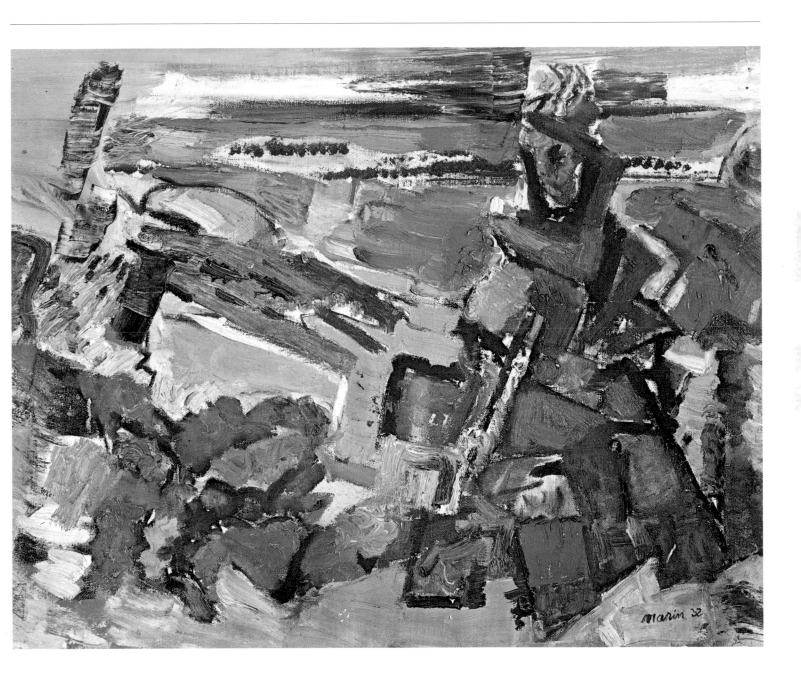

89] UNTITLED (FIGURES, DOWNTOWN NEW
YORK CITY), 1932
Pencil, 4½ x 6 1/16
Estate of the Artist, Courtesy of
Marlborough Gallery, Inc., New York

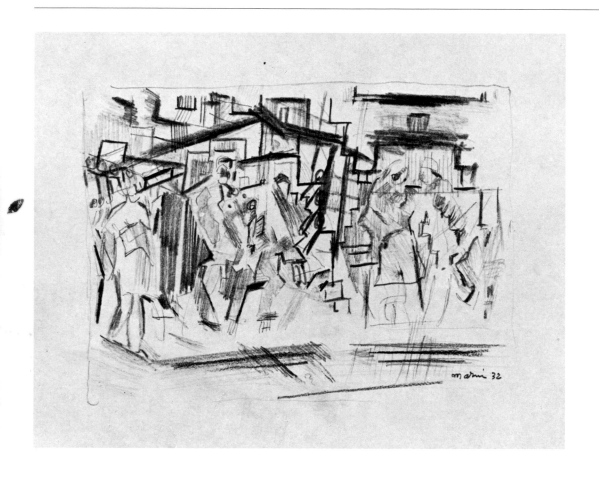

90] SAILBOAT, 1932
Etching, 7 x 9¼ (Zigrosser, No. 155)
Philadelphia Museum of Art, Philadelphia,
Pennsylvania, Given by Samuel Golden

91] ROCKS AND SEA, 1932
Oil on canvas, 20½ x 27
Estate of the Artist, Courtesy of
Marlborough Gallery, Inc., New York
(Illustrated)

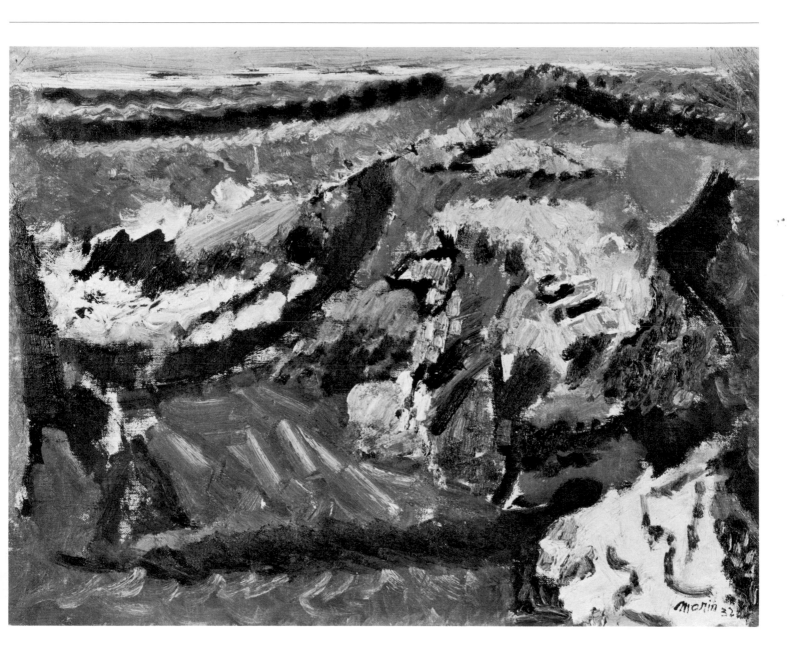

92] MID-MANHATTAN, NO. 1, 1932
Oil on canvas, 28 x 22
Des Moines Art Center, Des Moines, Iowa,
Nathan Emory Coffin Collection

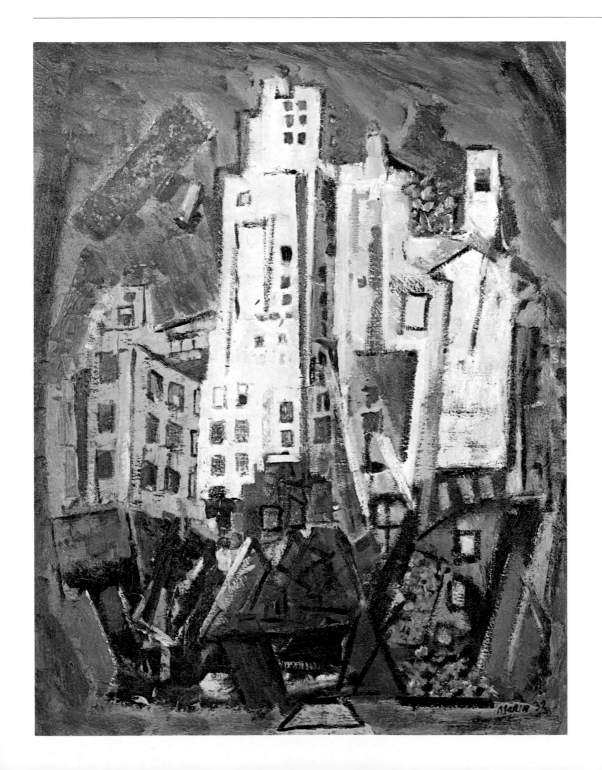

93] COMPOSITION, CAPE SPLIT, MAINE,
No. 3, 1933
Oil on canvas, 22 x 28
Santa Barbara Museum of Art, Santa Barbara,
California, Preston Morton Collection

94] SNOW, NEW JERSEY, 1933
Watercolor, 19 x 21¼
Private Collection
(Illustrated)

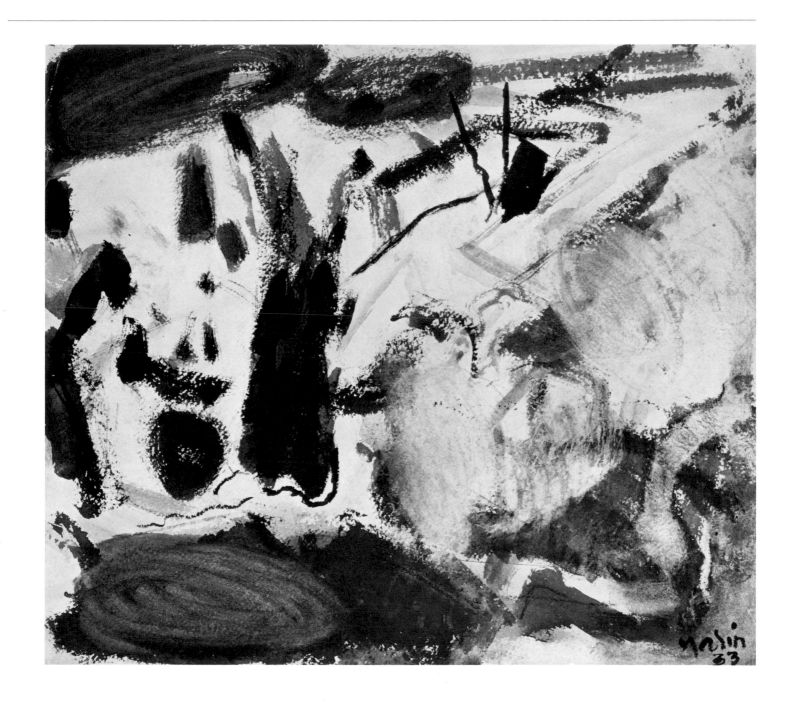

95] DEAD TREES AND SEA, 1934
Watercolor, 15 x 20
Estate of the Artist, Courtesy of
Marlborough Gallery, Inc., New York

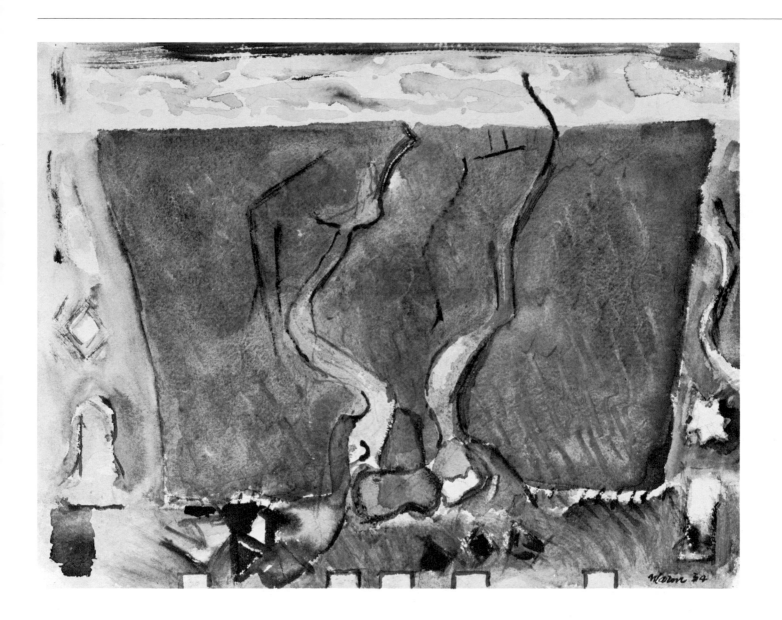

96] WOMEN FORMS AND SEA, 1934
Oil on canvas, 22 x 28
Private Collection

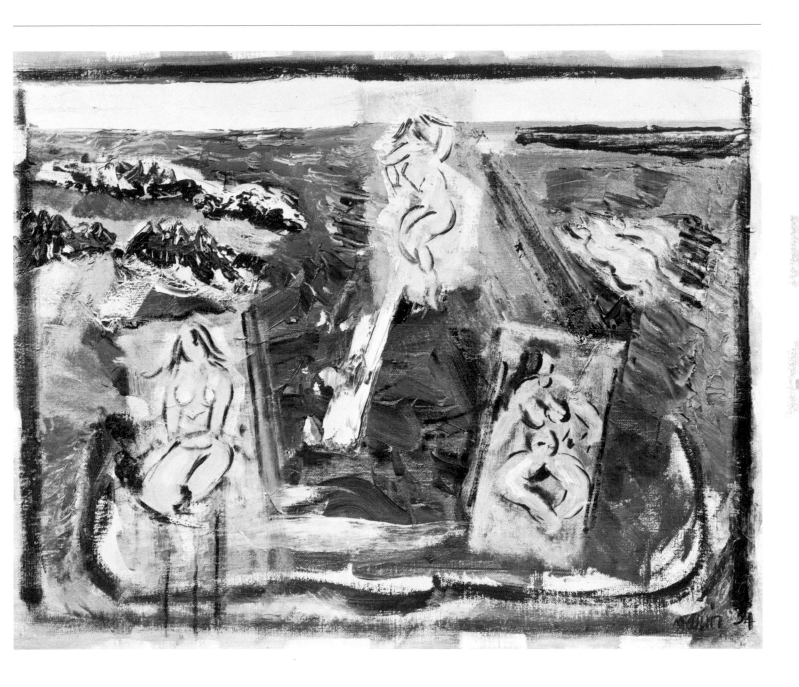

97] CAPE SPLIT, MAINE, 1935
Watercolor, 27 x 20½
Estate of the Artist, Courtesy of
Marlborough Gallery, Inc., New York

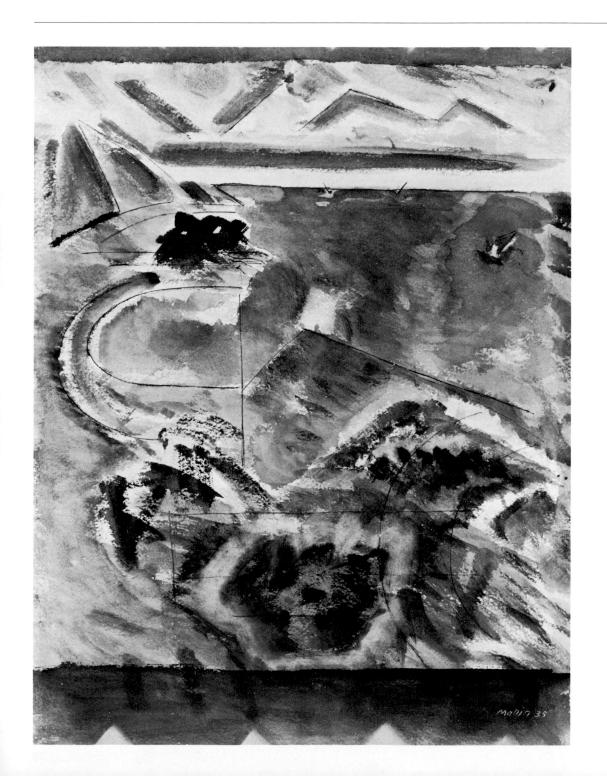

98] FIGURES, STREET MOVEMENT, 1935
Oil on canvas, 22 x 28
Private Collection
(Illustrated)

99] NEW YORK, HUDSON RIVER, 1936
Watercolor, 18½ x 23½ (sight)
Private Collection

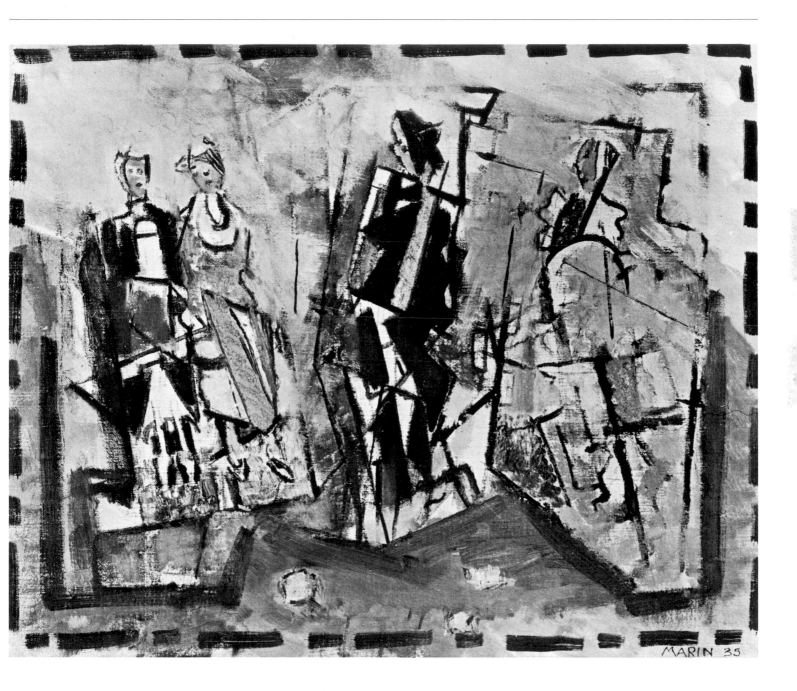

100] UNTITLED (NASSAU STREET, NEW
YORK CITY), 1936
Pencil, 7 x 5 9/16
Estate of the Artist, Courtesy of
Marlborough Gallery, Inc., New York

101] TOP OF RADIO CITY, NEW YORK, 1937
Watercolor, 20¾ x 24¾
Kennedy Galleries, Inc., New York

102] WAVE ON ROCK, 1937
Oil on canvas, 22½ x 30
Estate of the Artist, Courtesy of
Marlborough Gallery, Inc., New York
(Illustrated)

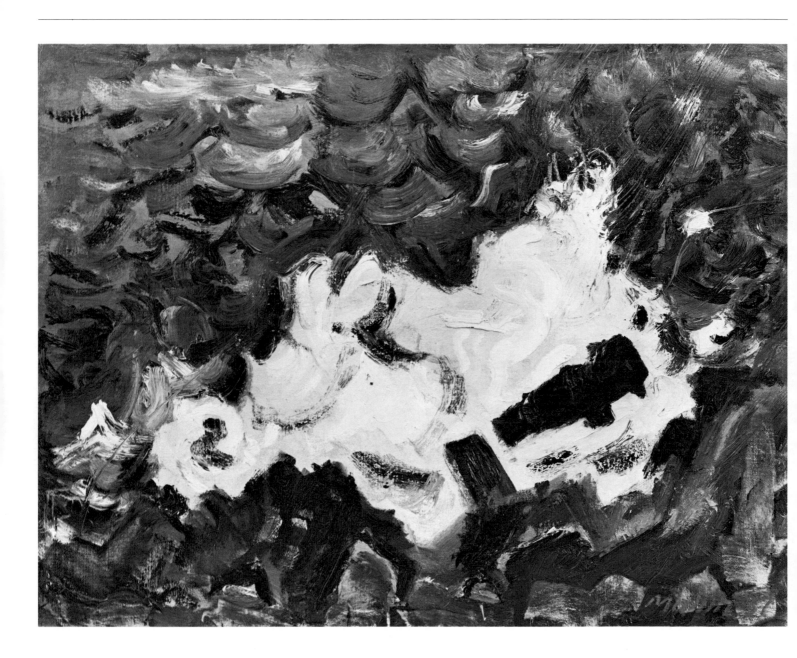

103] MAGNOLIAS, 1938
Oil on canvas, 18½ x 22½
Estate of the Artist, Courtesy of
Marlborough Gallery, Inc., New York

104] SOU'WESTER AT HEAD OF THE CAPE,
1938
Watercolor, 15½ x 20¾
Private Collection
(Illustrated)

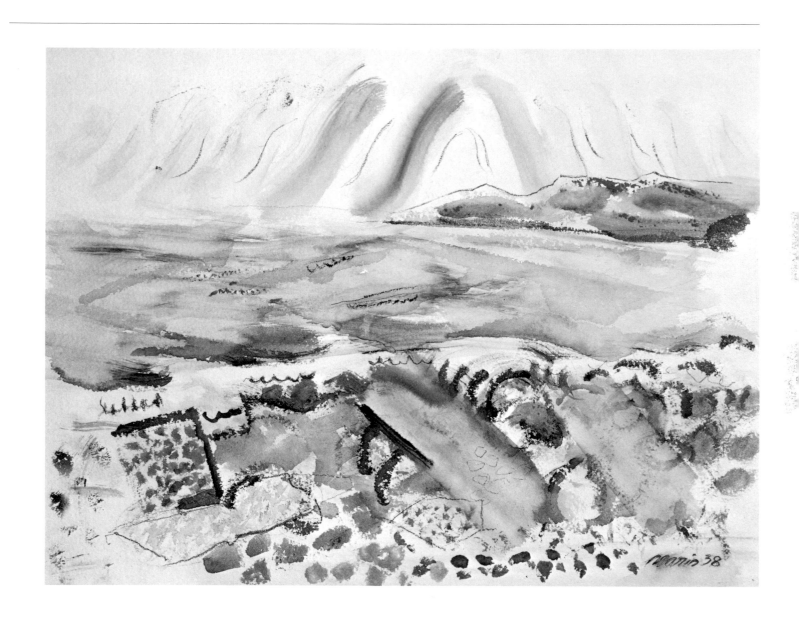

105] FROM THE HEAD OF THE CAPE, 1939
Watercolor, 15⅛ x 20¾
Private Collection

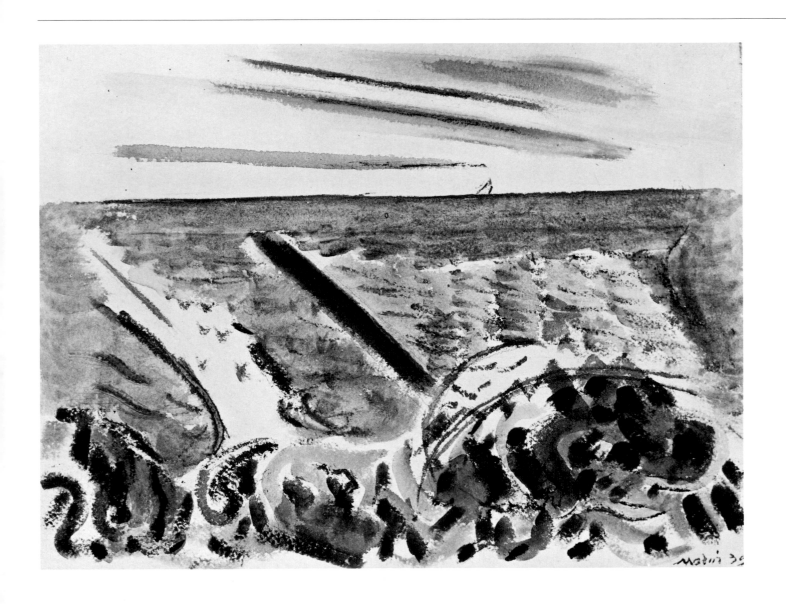

106] CIRCUS, about 1939
Colored pencil, 5½ x 7
Private Collection
(Illustrated)

107] WHITE MOUNTAINS, NEW HAMPSHIRE,
1939
Pencil, 7¾ x 9¼
Private Collection
(Illustrated)

108] PERTAINING TO THE SEA, CAPE SPLIT,
MAINE, 1940
Watercolor, 15 x 20¼
Dr. and Mrs. Herbert Koteen, New York

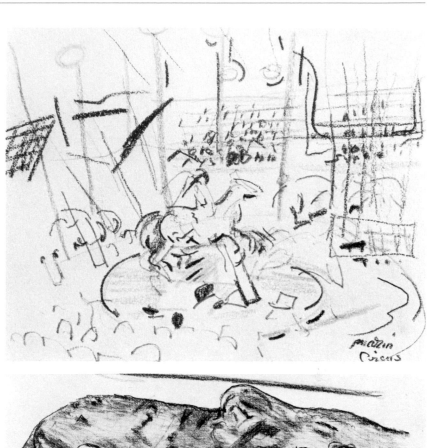

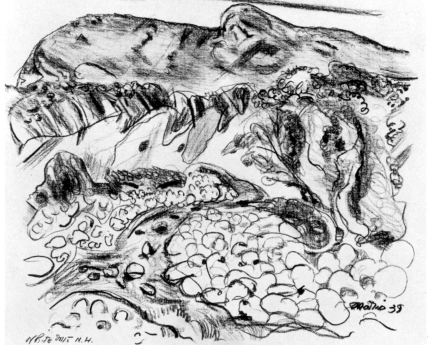

109] UNTITLED (LOBSTER BOAT, CAPE
SPLIT, MAINE), about 1940
Colored pencil, 7⅝ x 10⅛
Private Collection

110] PINK ROCKS AND GREEN SEA, 1940
Oil on canvas, 22½ x 28¼
Estate of the Artist, Courtesy of
Marlborough Gallery, Inc., New York

111] THE SEA, No. 3, 1940
Black crayon and pencil, 8½ x 10 ¹³⁄₁₆
National Gallery of Art, Washington, D.C.,
Gift of Frank and Jeannette Eyerly
(Illustrated)

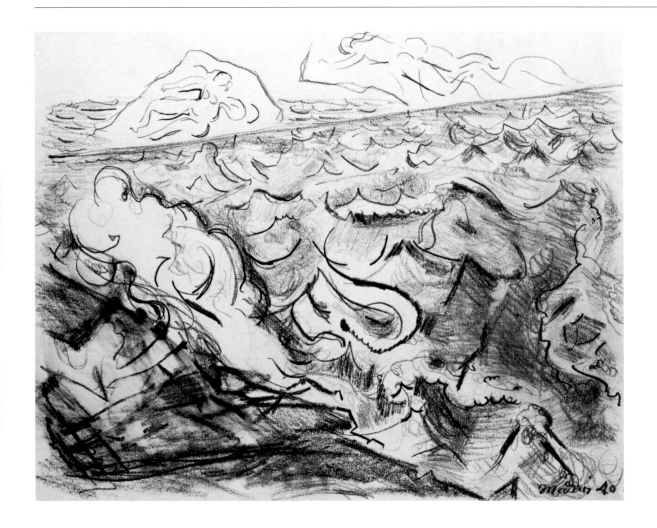

112] CIRCUS ELEPHANTS, 1941
Watercolor, 19³/₁₆ x 24¾
Art Institute of Chicago, Chicago, Illinois,
Alfred Stieglitz Collection and Waller Fund

113] LIONS IN THE RING, 1941
Watercolor, 8½ x 10½
Mr. and Mrs. Irving Brown, Brooklyn, New York
(Illustrated)

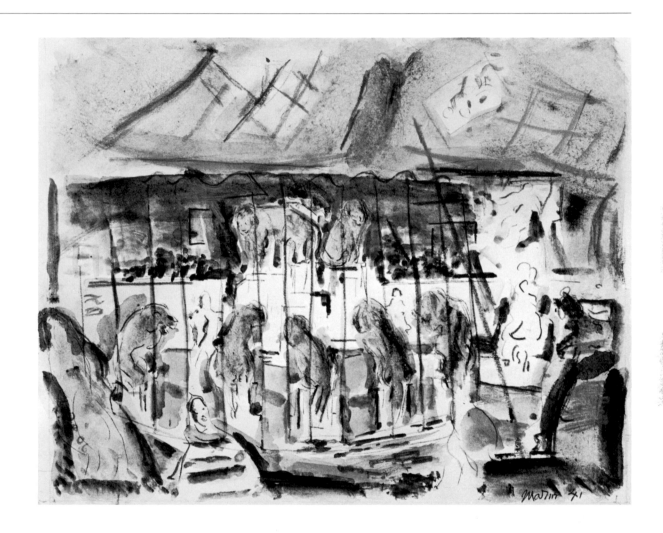

114] THE RISING SEA, MAINE, 1941
Oil on canvas, 24½ x 29¾
Private Collection

115] UNTITLED (SKYSCRAPERS, LOWER
MANHATTAN), about 1942
Pencil, 7 x 9¼
Estate of the Artist, Courtesy of
Marlborough Gallery, Inc., New York

116] COMPOSED FROM MY HOUSE,
OUTLOOKS, No. 1, 1942
Watercolor, 17⅜ x 22
Private Collection
(Illustrated)

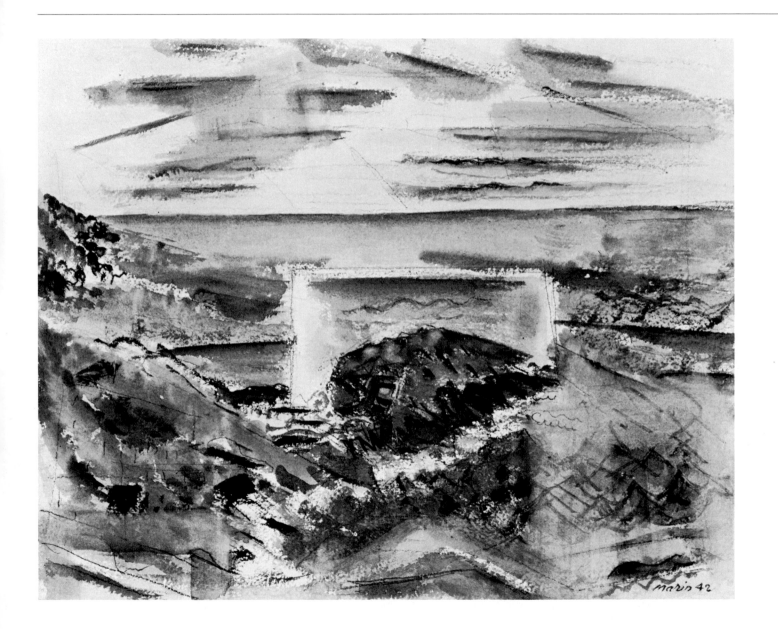

117] WAVES, 1943
Pencil, 10⅞ x 13⅞
Private collection

118] AUTUMN FOLIAGE, NORTHERN NEW
JERSEY, 1943
Watercolor, 15¼ x 20½
Private Collection
(Illustrated)

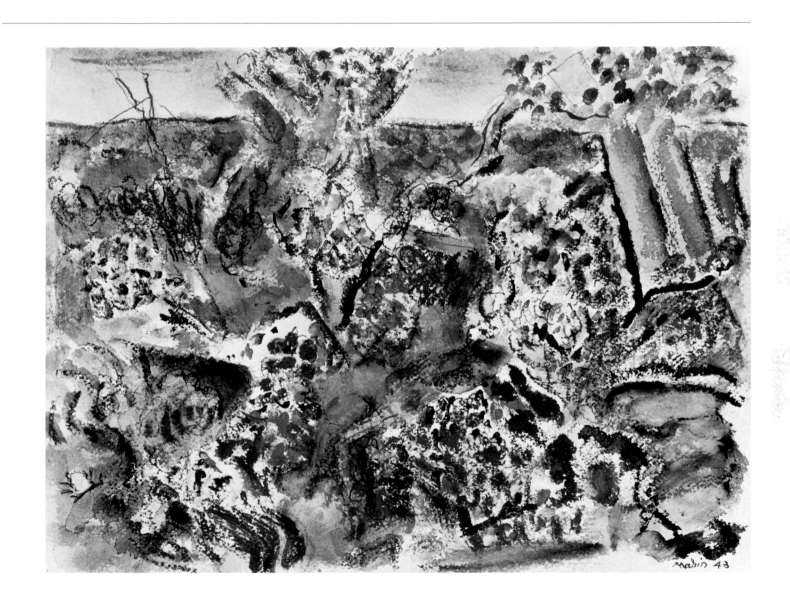

119] RELATED TO THE SEA, 1944
Watercolor, 15 x 20
Mr. and Mrs. Irving Brown, Brooklyn,
New York

120] RELATED TO HURRICANE, 1944
Oil on canvas, 22 x 28
Private Collection
(Illustrated)

121] UNTITLED (THE ELEPHANT), about 1944
Pencil, 6 1/16 x 8 7/16
Estate of the Artist, Courtesy of
Marlborough Gallery, Inc., New York

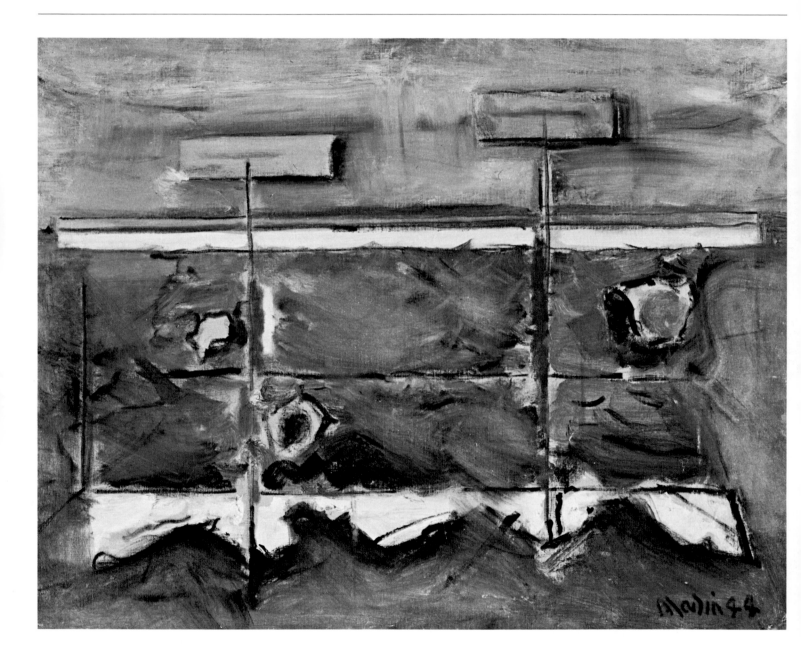

122] CIRCUS CLOWN, 1944
Oil on canvas, 30 x 25
Estate of the Artist, Courtesy of
Marlborough Gallery, Inc., New York
(Illustrated)

123] BROOKLYN BRIDGE — ON THE BRIDGE,
1944
Pencil, 6⅜ x 7¾
Private Collection

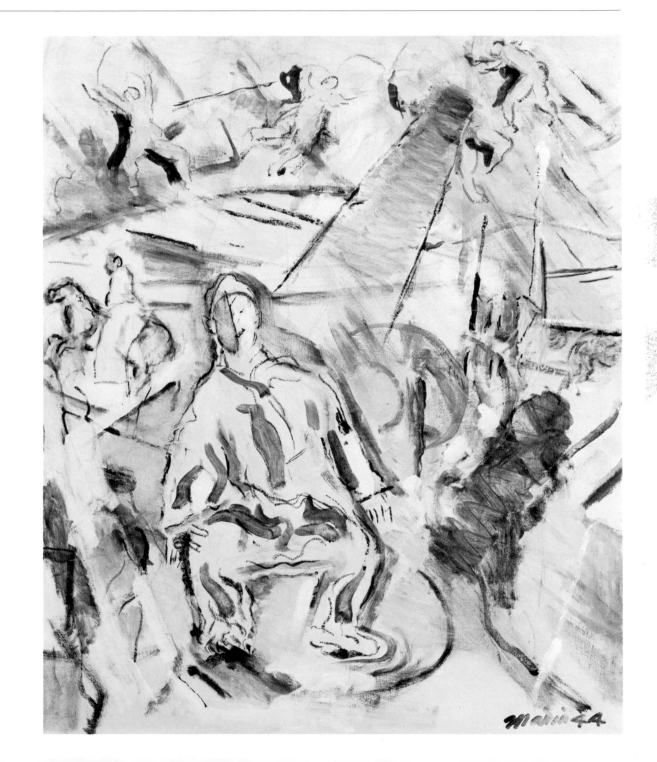

124] MARIN, 1945
Oil on canvas, 25 x 30
Private Collection

125] CAPE SPLIT, SEA (CERULEAN BLUE
AND LIGHT RED), 1945
Watercolor, 15¼ x 20½
Private Collection
(Illustrated)

126] MACHIAS, MAINE, 1945
Watercolor, 15¼ x 20⅝
Private Collection

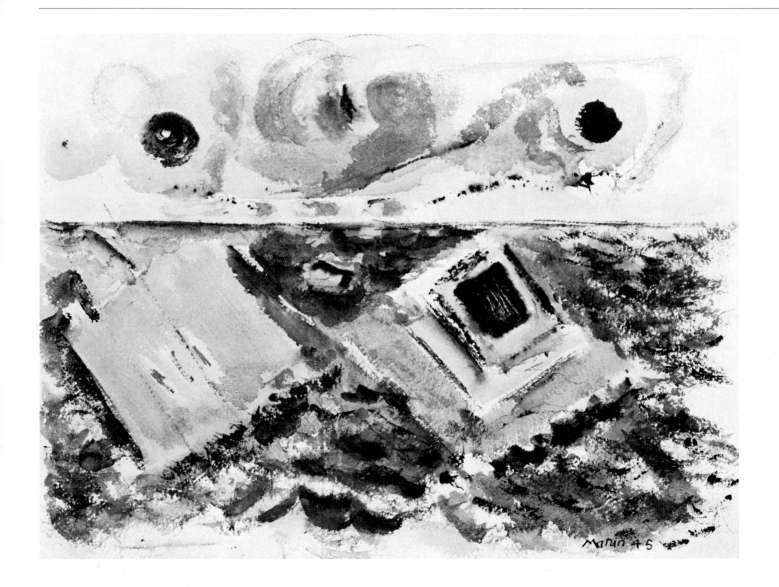

127] SELF PORTRAIT, 1945
Pencil, 7⅝ x 6
Private Collection

128] UNTITLED (TRAPEZE — CIRCUS), about
1945
Colored pencil, 9½ x 7¾
Private Collection

129] UNTITLED (CIRCUS — IN THE RING),
about 1945
Colored pencil, 8 x 10
Private Collection

130] MOVEMENT IN GREYS AND YELLOWS,
1946
Oil on canvas, 22 x 28
Private Collection
(Illustrated)

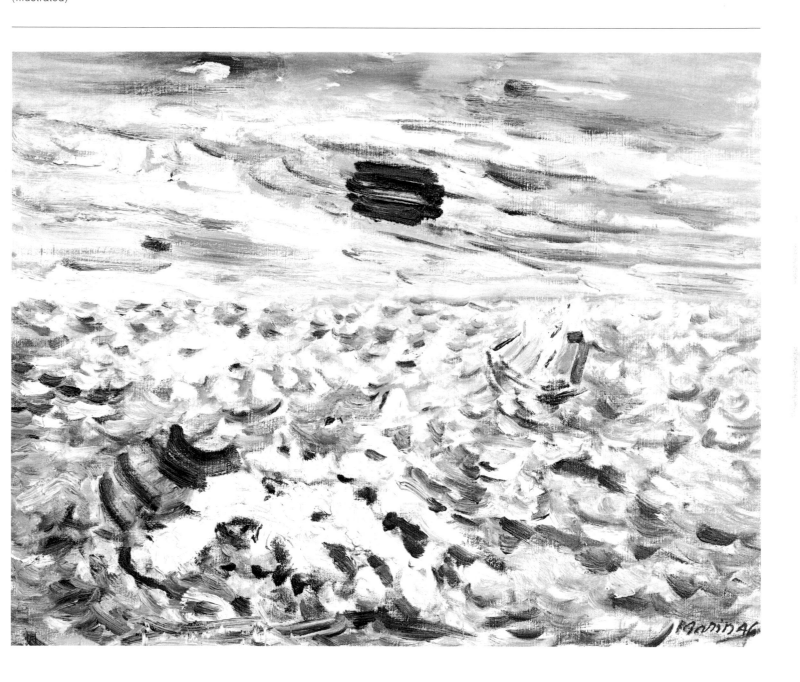

131] MOVEMENT, 1946
Oil on canvas, 23 x 28
Estate of the Artist, Courtesy of
Marlborough Gallery, Inc., New York

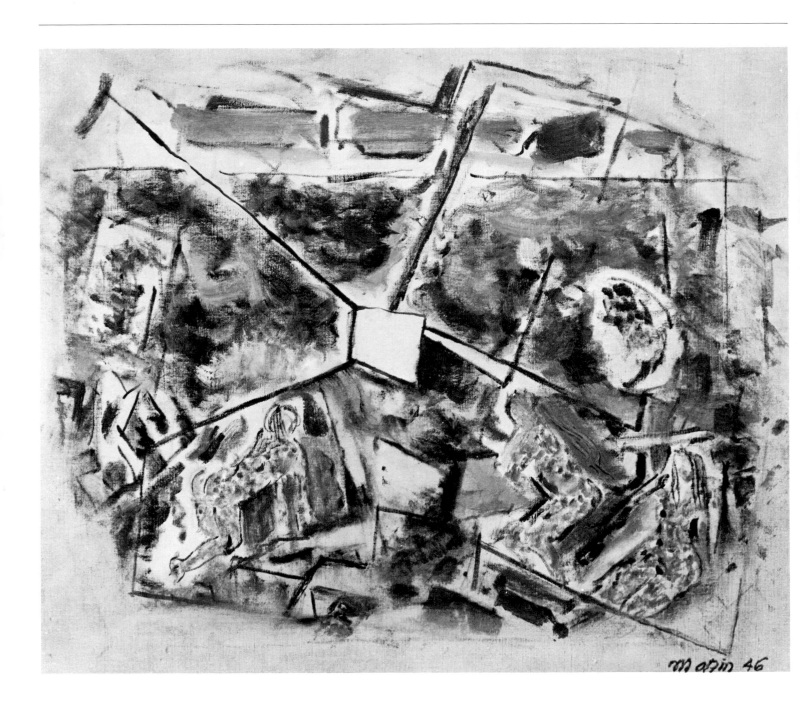

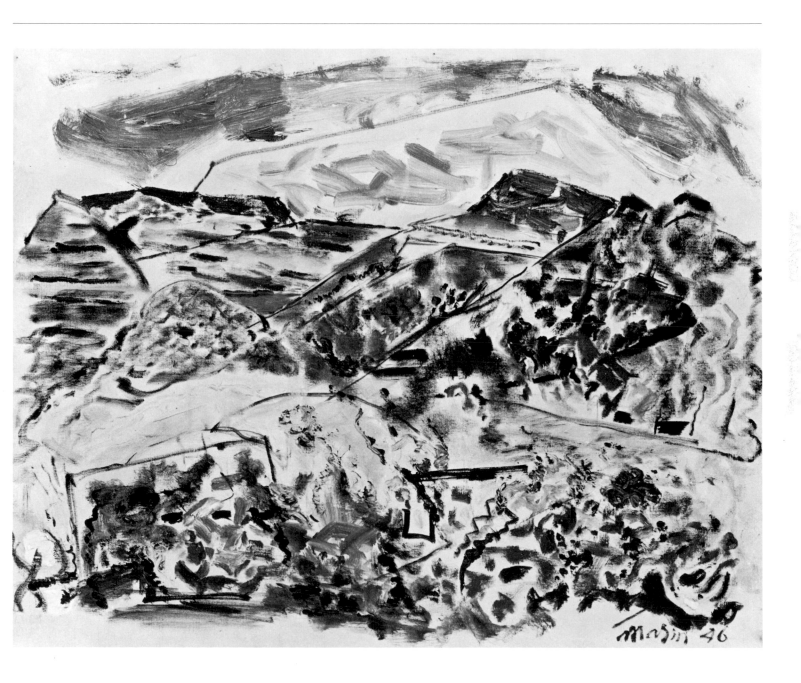

133] MOVEMENT: SEA PLAYED WITH BOAT
MOTIVE, 1947
Oil on canvas, 22 x 28
Kennedy Galleries, Inc., New York

134] MOVEMENT: SEAS AFTER HURRICANE,
RED, GREEN AND WHITE, FIGURE IN BLUE,
MAINE, 1947
Oil on canvas, 22 x 28
Private Collection
(Illustrated)

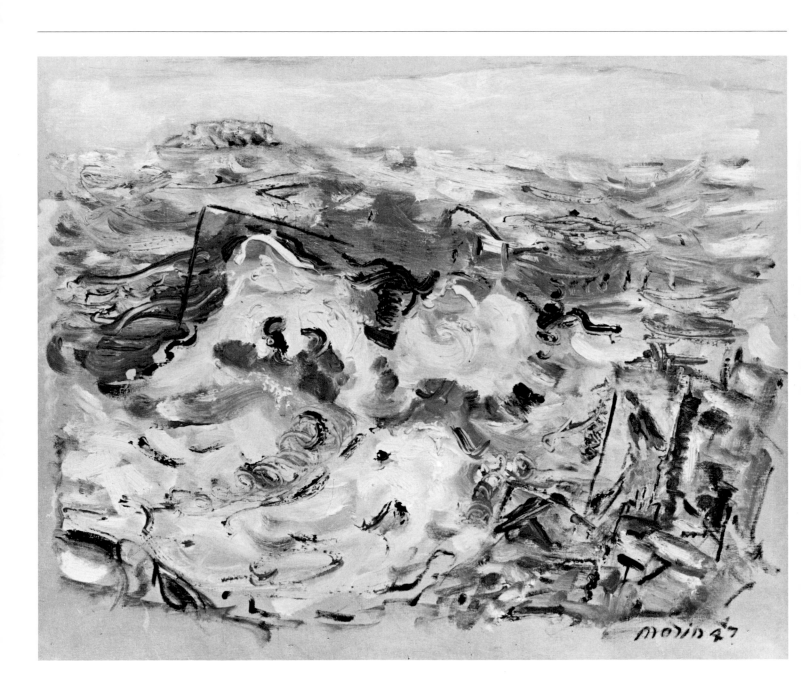

135] SEA AND ROCKS, MOUNT DESERT, MAINE,
1948
Oil on canvas, 22 x 28
Roy R. Neuberger, New York

136] FROM CAPE SPLIT, No. 2, 1948
Watercolor, 15 x 20½
Private Collection
(Illustrated)

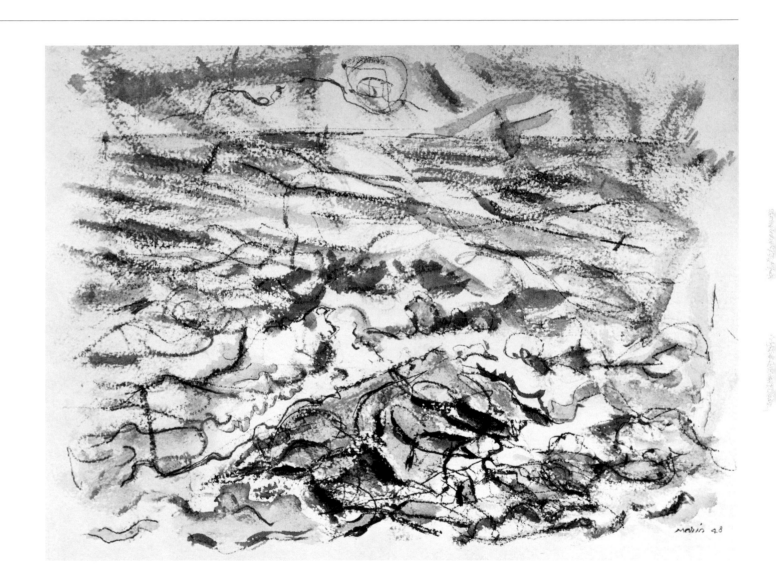

137] SEA WITH BOAT IN GREYS, GREENS
AND RED, 1948
Oil on canvas, 25 x 30
Private Collection
(Illustrated)

138] PEACH TREES IN BLOSSOM, No. 3, 1948
Watercolor, 16 x 19
Milwaukee Art Center Collection, Milwaukee
Wisconsin, Gift of Mrs. Harry Lynde Bradley

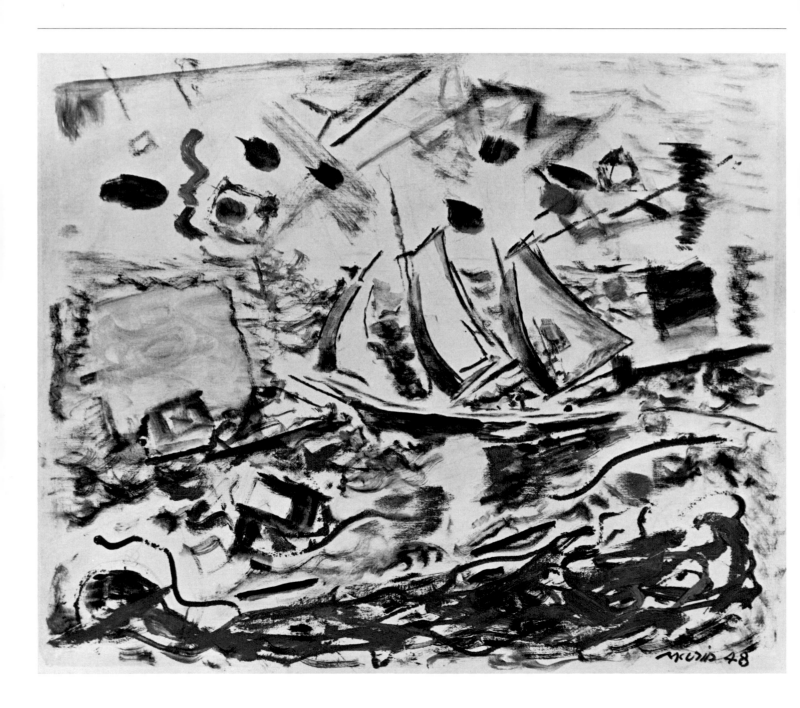

139] JERSEY HILLS, 1949
Oil on canvas, 24 x 29
Private Collection
(Illustrated)

140] HEAVY SEAS IN REDS AND GREENS,
1949
Oil on canvas, 24 x 29
Private Collection

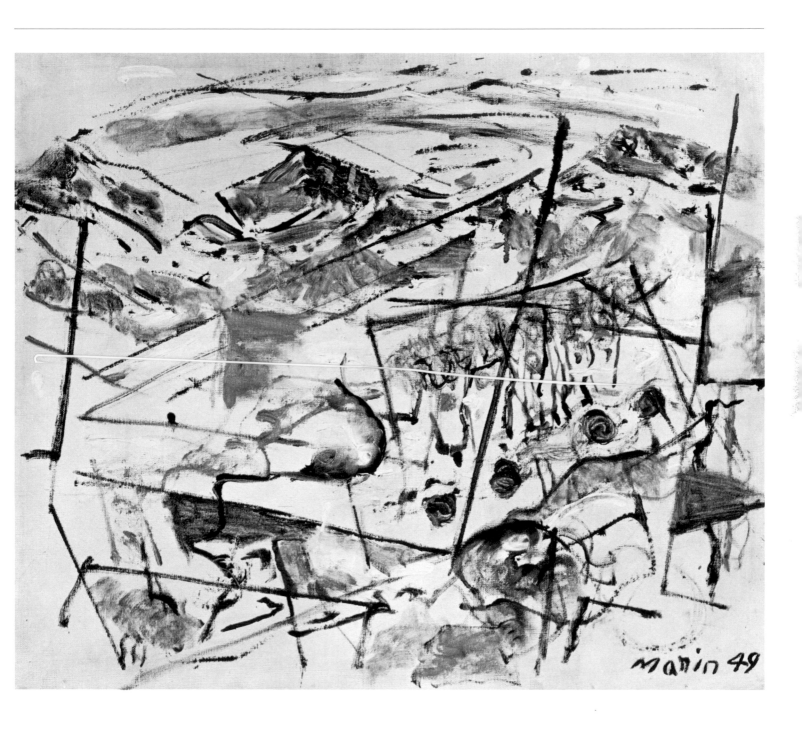

141] IN THE RAMAPOS, No. 2, 1949
Watercolor, 15 x 20½
Joseph H. Hirshhorn Foundation, Inc., New York

142] MOVEMENT IN LIGHT RED, CERULEAN
BLUE AND UMBER, 1950
Oil on canvas, 22 x 28
Private Collection
(Illustrated)

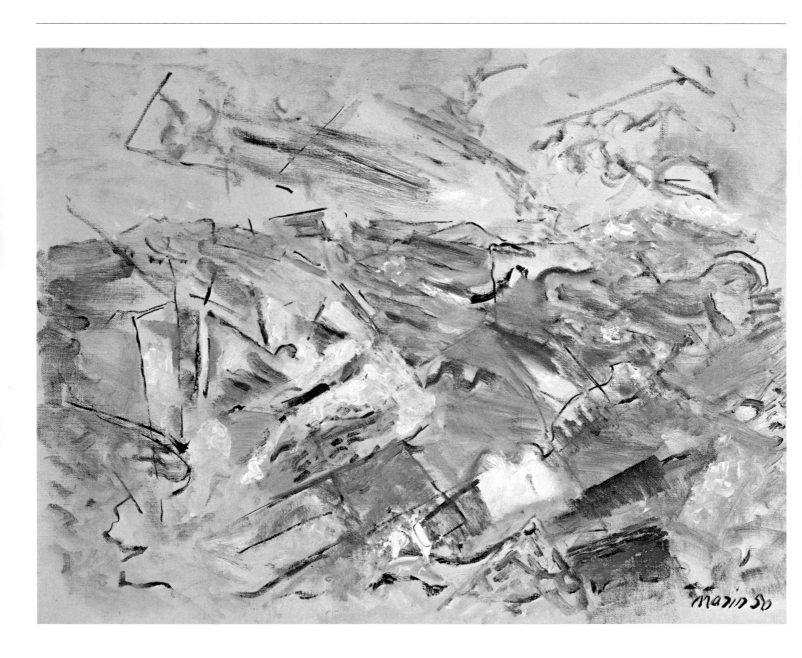

143] MOVEMENT IN RED, BLUE AND UMBER,
1950
Oil on canvas, 22 x 28
Private Collection
Estate of the Artist, Courtesy of
Marlborough Gallery, Inc., New York

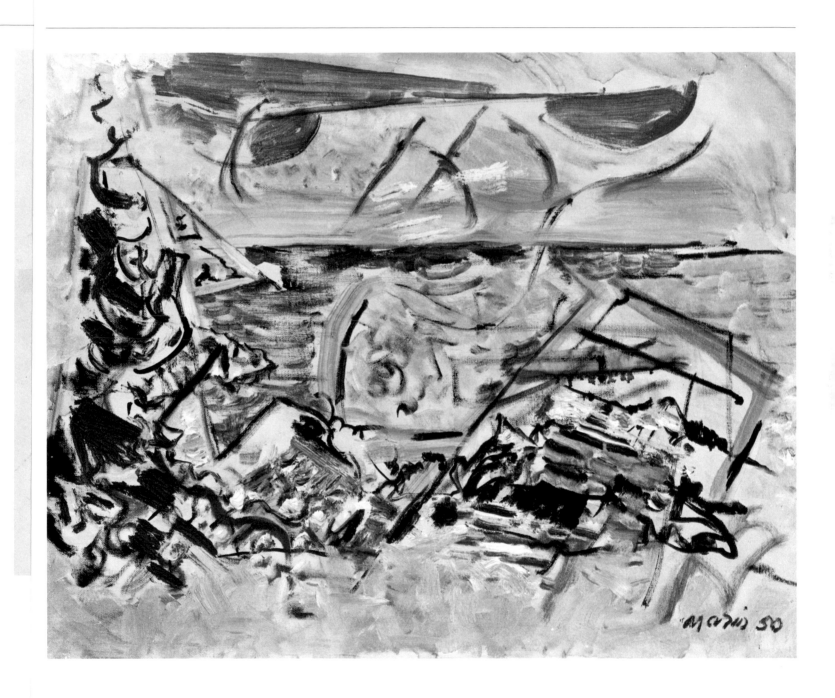

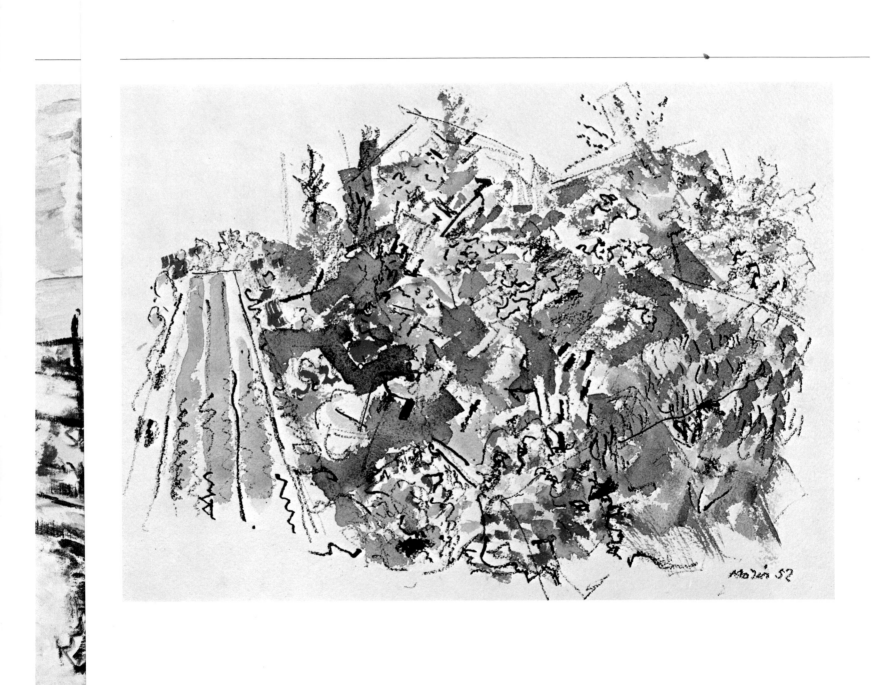

151] BEACH, FLINT ISLAND, MAINE, 1952
Oil on canvas, 21 ¾ x 28 ¼
Estate of the Artist, Courtesy of
Marlborough Gallery, Inc., New York

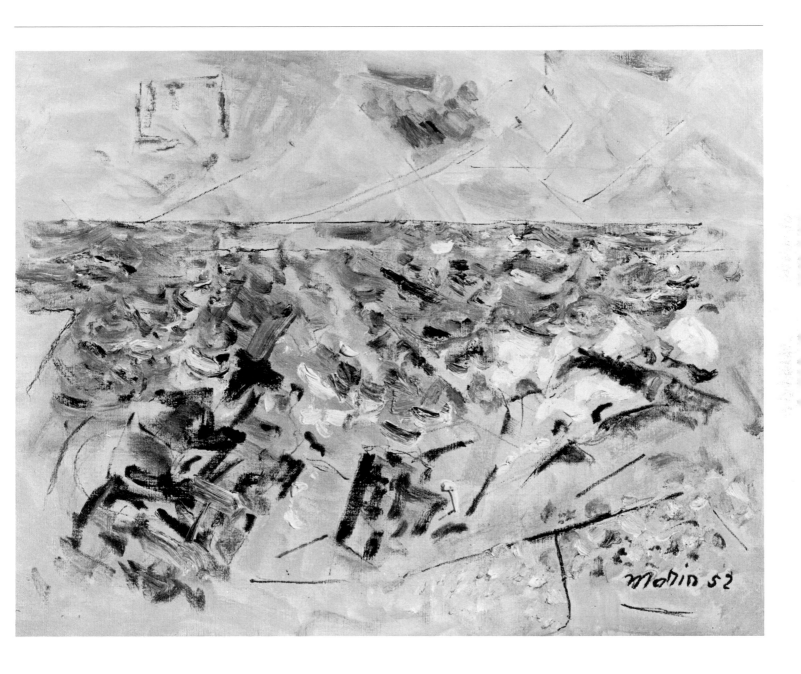

152] PEACH TREES IN BLOSSOM, SADDLE
RIVER, NEW JERSEY, 1952
Watercolor, 14⅞ x 20
Estate of the Artist, Courtesy of
Marlborough Gallery, Inc., New York

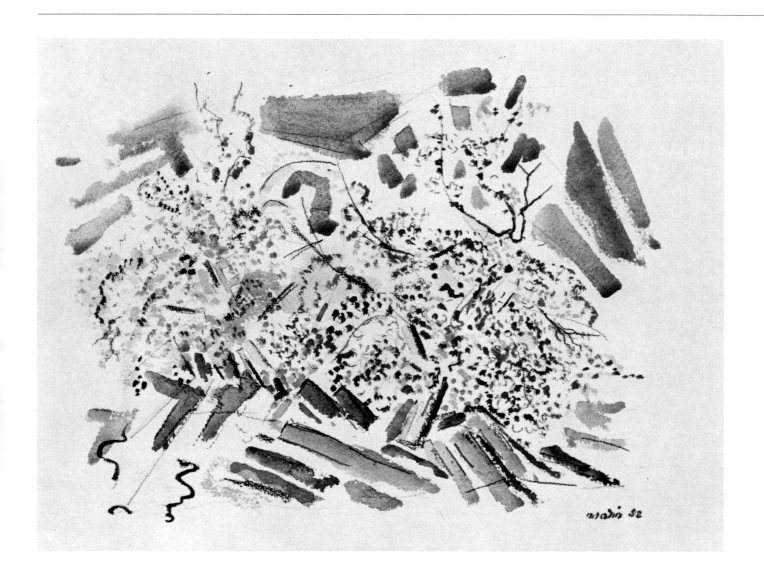

153] APPROACHING FOG, 1952
Watercolor, 14½ x 19
Private Collection

154] THE WRITTEN SEA, 1952
Oil on canvas, 22 x 28
Private Collection
(Illustrated)

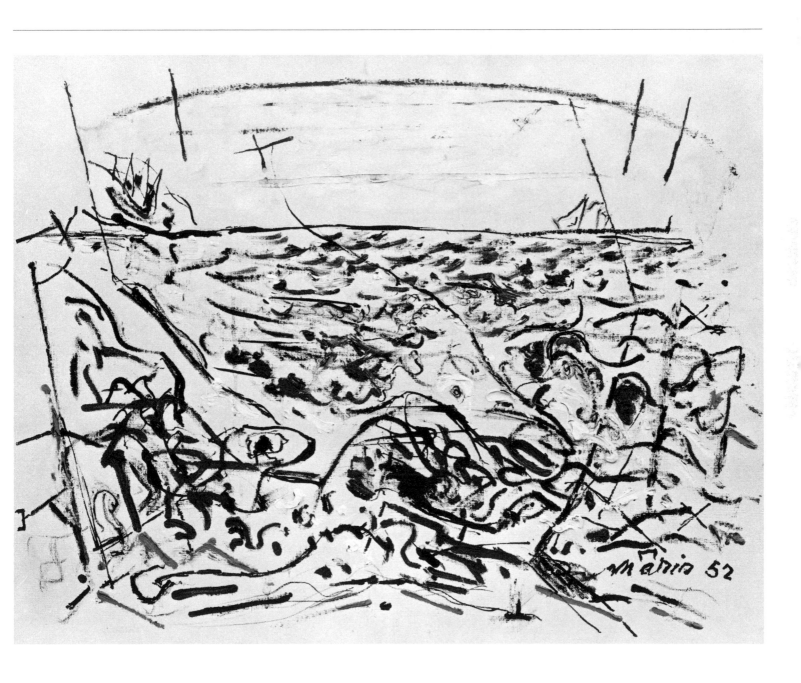

155] SPRING, No. 2, 1953
Oil on canvas, 22 x 28
Mr. and Mrs. John Marin, Jr., New York
(Illustrated)

156] THE CIRCUS, 1953
Oil on canvas, 18 x 22
Estate of the Artist, Courtesy of
Marlborough Gallery, Inc., New York

157] UNTITLED (BASEBALL), 1953
Colored pencil, 8½ x 11
Private Collection

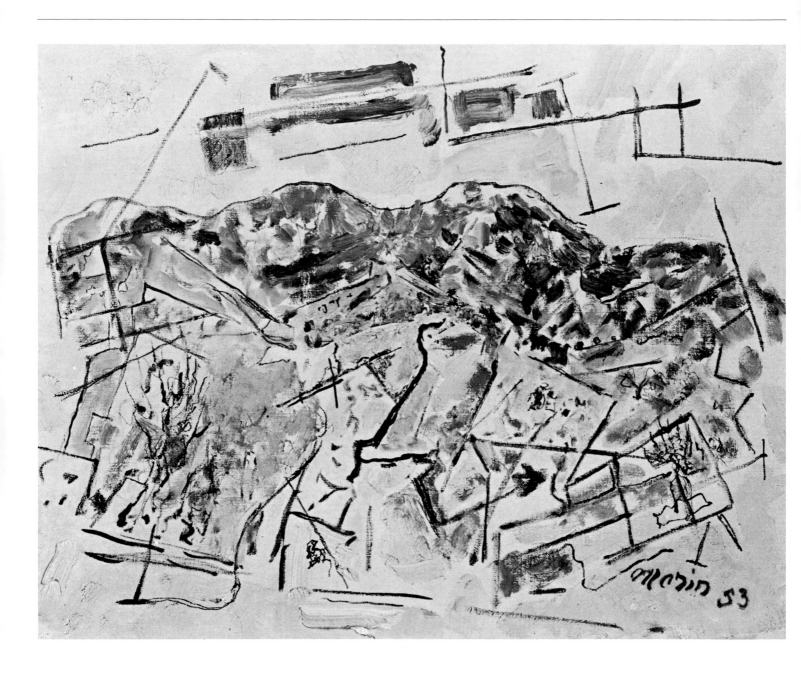

LENDERS TO THE EXHIBITION

Art Institute of Chicago, Illinois

Mr. and Mrs. Irving Brown, Brooklyn, New York

Andrew J. Crispo, New York

Des Moines Art Center, Iowa

Mr. and Mrs. Donald S. Gilmore, Kalamazoo, Michigan

Mr. and Mrs. Harry Goldblatt, New York

Joseph H. Hirshhorn Foundation, Inc., New York

Kennedy Galleries, Inc.

Dr. and Mrs. Herbert Koteen, New York

Dr. and Mrs. Irving Levitt, Southfield, Michigan

Mr. and Mrs. John Marin, Jr., New York

Mr. and Mrs. John Marin, Jr. Foundation, Inc., New York

Lisa Marie Marin, New York

Marlborough Gallery, Inc., New York

Mr. and Mrs. William L. McLennan, Lake Forest, Illinois

The Metropolitan Museum of Art, New York

Milwaukee Art Center, Inc., Wisconsin

Museum of Modern Art, New York

National Gallery of Art, Washington, D.C.

Roy R. Neuberger, New York

Mrs. Dorothy Norman, New York

Philadelphia Museum of Art, Pennsylvania

The Phillips Collection, Washington, D.C.

Dr. and Mrs. Harold Rifkin, Riverdale, New York

Santa Barbara Museum of Art, California

Mr. and Mrs. John Schulte, New York

The Wilmington Society of the Fine Arts, Delaware

CATALOG INDEX

*Illustrated

1. Mackinley Helm, *John Marin.* Boston: Pellegrini & Cudahy in association with the Institute of Contemporary Art, 1948, p. 4

2. For biographical information see Helm, *op. cit.*

3. Quoted by Dorothy Norman, *The Selected Writings of John Marin.* New York: Pellegrini & Cudahy, 1949, p. ix

4. Probably the drawing described by Helm, *op. cit.,* p. 11

5. *Ibid.,* pp. 9-10

6. See his forthcoming John Marin, *A Stylistic Analysis and Catalogue Raisonné,* University of Arizona Press

7. Quoted by Dorothy Norman, *op. cit.,* p. 78

8. Carl Zigrosser, *The Complete Etchings of John Marin.* Philadelphia Museum of Art, 1969, p. 11

9. Norman, *op. cit.,* pp. viii-ix, x

10. *Ibid.,* p. xi

11. *Ibid.,* pp. 3-4

12. Norman, *op. cit.,* pp. 4-5

13. Sheldon Reich, "John Marin: Paintings of New York, 1912," *The American Art Journal,* vol. I, no. 1, Spring 1969, pp. 43-52

14. Helm, *op cit.,* p. 37

15. See Sheldon Reich, "John Marin, Cubism and Abstraction," *Auction,* vol. III, no. 5, pp. 42-43

16. Norman, *op. cit.,* p. 45

17. *Ibid.,* p. 46

18. *Ibid.,* p. 59

19. "John Marin, By Himself," *Creative Art,* October 1928, quoted by Norman, *op. cit.,* p. 126

20. E. M. Benson, *John Marin, The Man and His Work.* Washington, 1935, p. 70

21. Heinrich Riegner, "John Marin," *Werk,* vol. 35, August 1948, p. 266

22. Norman, *op. cit.,* p. 194

23. Frederick S. Wight, John Marin, Mackinley Helm, *John Marin: A Retrospective Exhibition.* Boston: Institute of Modern Art, 1947, p. 12

24. Helm, *op. cit.,* p. 101

25. "John Marin, By Himself," *Creative Art,* October 1928, quoted by Norman, *op. cit.,* p. 125

SELECTED BIBLIOGRAPHY

Books and Monographs

Hartley, Marsden. *Adventures in the Arts.* New York: Boni & Liveright, 1921.

Gallatin, Albert Eugene. *American Water-Colourists.* New York: E. P. Dutton & Co., 1922.

Rosenfeld, Paul. *Port of New York — Essays on Fourteen American Moderns.* New York: Harcourt Brace & Co., 1924.

Seligmann, H. J., editor. *Letters of John Marin.* New York: An American Place, 1931.

Frank, Waldo *et al. America and Alfred Stieglitz.* New York: Literary Guild, 1934.

Benson, E. M. *John Marin, The Man and His Work.* Washington, 1935.

Flint, Ralph. *John Marin, American Art Portfolios.* New York: Raymond & Raymond, Inc., 1936.

Goodrich. Lloyd. *American Watercolor and Winslow Homer.* Minneapolis: The Walker Art Center, 1945.

Helm, MacKinley. *John Marin.* Boston: Pellegrini & Cudahy, 1948.

Larkin, Oliver W. *Art and Life in America.* New York: Rinehart & Co., 1949.

Norman, Dorothy. *The Selected Writings of John Marin.* New York: Pellegrini & Cudahy, 1949.

Baur, John Ireland Howe. *Revolution and Tradition in Modern American Art.* Cambridge: Harvard University Press, 1951.

Brown, Milton Wolf. *American Painting from the Armory Show to the Depression.* Princeton: Princeton University Press, 1955.

Richardson, Edgar Preston. *Painting in America: The Story of 450 Years.* New York: Thomas Crowell Co., 1956.

Hunter, Sam. *Modern American Painting and Sculpture.* New York: Dell Publishing Co., Inc., 1959.

Geldzahler, Henry. *American Painting in the Twentieth Century.* New York: Metropolitan Museum of Art, 1965.

Gardner, Albert Ten Eyck. *History of Water Color Painting in America.* New York: Reinhold Publishing Co., 1966.

Rose, Barbara. *American Art Since 1900; A Critical History.* New York: F. A. Praeger, 1967

Reich, Sheldon. *John Marin: A Stylistic Analysis and a Catalogue Raisonné.* Tucson: University of Arizona Press, 1970 (in press).

Exhibition Catalogs

McBride, Henry and E. M. Benson. *John Marin: Watercolors, Oil Paintings, Etchings.* New York: Museum of Modern Art, 1936.

Wight, Frederick S. and MacKinley Helm. *John Marin: A Retrospective Exhibition.* Boston Institute of Modern Art, 1947.

John Marin: Water Colors, Oils, Prints and Drawings. Utica: Munson-Williams-Proctor Institute, 1951.

John Marin: 1870-1953. Detroit: The Detroit Institute of Arts, 1954.

James, Philip and Duncan Phillips. *John Marin: Paintings, Water-colours, Drawings, and Etchings.* London: Arts Council Gallery, 1956.

Wight, Frederick S. *et. al. John Marin.* Los Angeles and Berkeley: The University of California Press, 1956.

Buckley, Charles E. *John Marin in Retrospect.* Washington, D.C. and Manchester, N.H.: The Corcoran Gallery of Art and the Currier Gallery of Art, 1962.

Helm, MacKinley and Sheldon Reich. *John Marin, 1870-1953.* Tucson: University of Arizona Art Gallery, 1963.

John Marin (1870-1953) Retrospective Exhibition of Watercolours. London: The Waddington Galleries, 1963.

Reich, Sheldon and Donald Brewer. *Marsden Hartley and John Marin.* La Jolla Museum of Art, 1966.

Coke, Van Deren. *Marin in New Mexico/1929 & 1930.* Albuquerque: University Art Museum, University of New Mexico, 1968.

Reich, Sheldon, *John Marin: Oils, Watercolors, and Drawings Which Relate to His Etchings.* Philadelphia Museum of Art, 1969.

Zigrosser, Carl. *The Complete Etchings of John Marin (a fully illustrated and annotated catalogue raisonné).* Philadelphia Museum of Art, 1969.

Reich, Sheldon. *John Marin, Drawings, 1886-1951.* Salt Lake City: University of Utah, Museum of Fine Arts, 1969.

Periodicals

Saunier, Charles. "John Marin-Peintre-Graveur," *L'Art Decoratif,* XVIII (Jan. 1908), 17-24.

MacColl, William D. "Exhibition of Water-Colors, Pastels and Etchings by John Marin," *Camera Work,* No. 30 (April 1910), 41-44.

Taylor, E. A. "The American Colony of Artists in Paris," *The Studio,* LIII (July 1911), 103-118.

Laurvik, J. Nilsen. "The Water-Colors of John Marin," *Camera Work,* No. 39 (July 1912), 36-38.

"Critical Reaction to Marin's 1912 exhibition at '291'" *Camera Work,* Nos. 42-43 (April-July 1913), 22-43.

"Critical Reaction to Marin's 1915 and 1916 Exhibitions at '291'" *Camera Work,* No. 48 (Oct. 1916), 20-54.

Ryerson, Margery Austen "John Marin's Water Colors," *Art in America,* IX (Feb. 1921), 86-88, 91.

Strand, Paul. "John Marin," *Art Review,* I (Jan. 22, 1922), 22-23.

Craven, Thomas J. "John Marin," *The Nation,* CXVIII (Mar. 19, 1924), 321.

Eglington, Guy. "John Marin, Colorist and Painter of Sea Moods," *Arts and Decoration,* XXI (Aug. 1924), 31-34, 65.

Kalonyme, Louis. "John Marin, Promethean," *Creative Art,* III (Oct. 1928), xl-xli.

Marin, John. "John Marin by Himself," *Creative Art,* III (Oct. 1928), xxxv-xxxix.

Strand, Paul. "Marin Not an Escapist," *New Republic,* LV (July 25, 1928), 254-255.

Barker, Virgil. "John Marin," *Art & Understanding,* I (Nov. 1929), 106-109.

Rosenfeld, Paul. "Marin Show," *New Republic,* LXII (Feb. 26, 1930), 48-50.

Phillips, Duncan. "The Artist Sees Differently," *Phillips Memorial Gallery Bulletin,* I (1931), 128-132.

Rosenfeld, Paul. "An Essay on Marin," *The Nation,* CXXXIV (Jan. 27, 1932), 122-124.

Benson, E. M. "John Marin: The Man and His Work, Part I: The Man," *American Magazine of Art,* XXVIII (Oct. 1935), 597-611, 632-633; "Part II: Marin, His Work" (Nov. 1935), 655-670.

Rosenfeld, Paul. "John Marin's Career," *New Republic,* XC (April 14, 1937), 289-292.

Riegner, Heinrich. "John Marin," *Werk,* XXXV (Aug. 1948), 263-268.

Mellquist, Jerome. "John Marin: Painter of Specimen Days," *American Artist,* XIII (Sept. 1949), 56-59, 67-69.

Finkelstein, Louis. "Marin and DeKooning," *Magazine of Art,* XLIII (Oct. 1950), 202-206.

McBride, Henry. "Four Transoceanic Reputations," *Art News,* XLIX (Jan. 1951), 26-29, 66.

Norman, Dorothy. "Conversations with Marin," *Art News,* LII (Dec. 1953), 38-39, 57-59.

Mellquist, Jerome. "John Marin: Rhapsodist of Nature," *Art Journal,* XIII (1954), 310-312.

Norman, Dorothy. "John Marin: Conversations and Notes," *Art Journal,* XIV (1955), 320-331.

Porter, Fairfield. "The Nature of John Marin," *Art News,* LIV (Mar. 1955), 24-27, 63.

Soby, James Thrall. "Paintings of John Marin; excerpt," *Perspectives U.S.A.* No. 11 (1955), 48-55.

Newhall, Beaumont. "Day with John Marin," *Art in America,* XLIX, No. 2 (1961), 48-55.

Davidson, Abraham A. "Cubism and the Early American Modernist," *Art Journal* XXVI, No. 2 (Winter, 1966-67), 122-128.

Grey, Cleve and Dorothy Norman. "John Marin's Sketchbook — Summer 1951," *Art in America,* LV (Sept.-Oct. 1967), 44-53.

Reich, Sheldon. "John Marin: Cubism and Abstraction," *Auction* III, No. 4 (Jan. 1970), 40-43.

Designed in Los Angeles by Roger Kennedy,
12,500 copies of the catalog were lithographed by
Koltun Brothers. Typography is Helvetica Light.

Plate photographs are by Otto E. Nelson, New York,
with the following exceptions: Philadelphia Museum
of Art, page 28; The Metropolitan Museum of Art,
pages 29, 45, 54; Oliver Baker, New York, pages 38,
41, 57; Art Institute of Chicago, page 50; John D. Schiff,
page 53; Fraser Fletcher, Des Moines Art Center, page
60; National Gallery of Art, page 70.